Unfamiliar Underground

FINDING THE CALM IN THE CHAOS OF LONDON'S TUBE STATIONS

VICTORIA LOUISE HOWARD

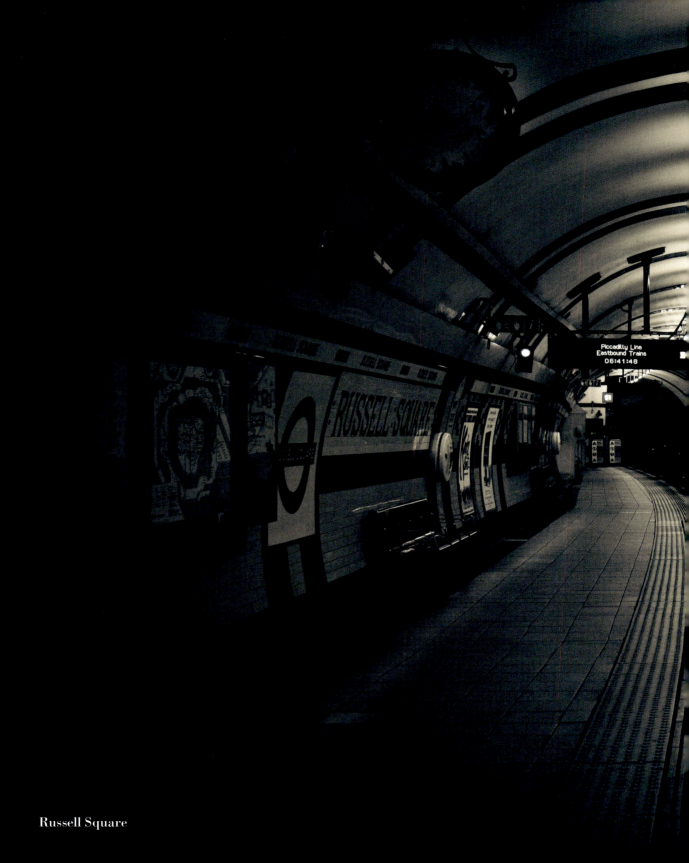

Russell Square

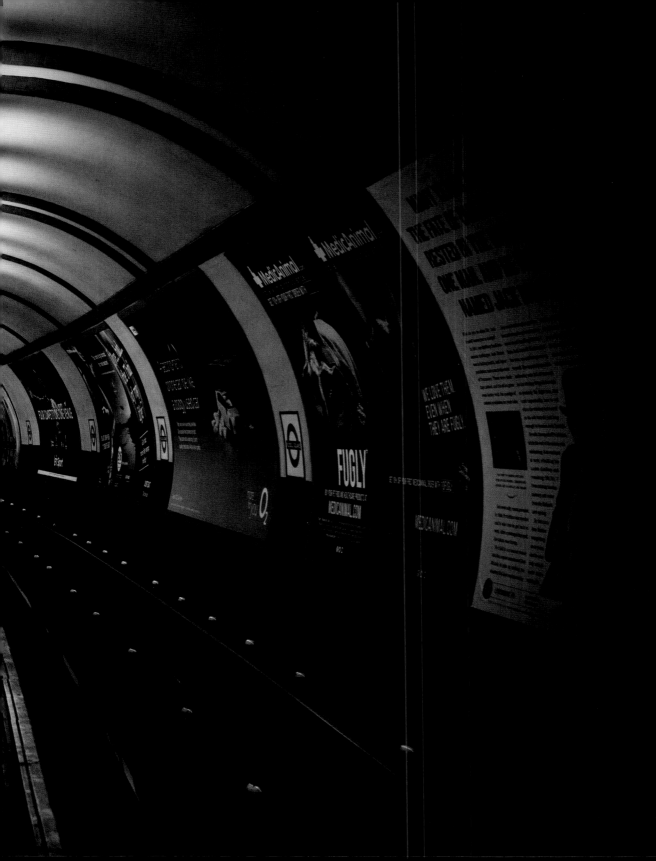

For my Mum and Dad,
To the moon and back.

Victoria.

First published 2019

The History Press
The Mill, Brimscombe Port
Stroud, Gloucestershire, GL5 2QG
www.thehistorypress.co.uk

Text © Victoria Louise Howard, 2019
Photographs © Victoria Louise Howard, 2019

British Library Cataloguing in Publication Data.
A catalogue record for this book is available from the British Library.

ISBN 978 0 7509 9056 1

Designed by Jemma Cox
Printed in Turkey by Imak

Introduction

The London Underground is the oldest underground transport system in the world. Built in 1863, it has undergone various upgrades and expansions in its 155-year history. The network currently serves upwards of 1 billion passengers every year across 270 stations. It therefore seems strange that any of these stations should ever be empty, or that any Tube carriage could be passenger free. But for the past five years, seeking out this empty state has been my overriding purpose. I wanted to photograph the Tube in way that few people ever experience: An Unfamiliar Underground.

Living with anxiety is difficult to describe. Realising and facing your own fears head-on is even harder. An incident at a busy London station twelve years ago has left me with a profound fear of bustling crowds and busy stations, and anxiety has been my constant shadow. For years I couldn't travel on a train. It has left me frightened and at times in tears, unable to feel I could move forward. Anxiety makes you feel very isolated and alone in the world.

Fast forward seven years to when I was at university, my love of photography and a specific assignment led me to face those fears and step outside of my comfort zone. I was terrified but forced to confront what haunted me. The assignment was to photograph London in an alternative way, to explore our creativity. That seems like a daunting task when you consider how vast and diverse London is. While travelling around London, trying to find inspiration, an idea came to mind, albeit a crazy one. In 2013 it was the 150th anniversary of the London Underground opening and there were posters celebrating this everywhere. What if I could photograph the Tube in an alternative way? After all, it is one of the most famous attractions in London, as well as one of the busiest.

I wanted to photograph the stations when they were empty. To create a sense of stillness and quiet in a place usually bustling with commuters and tourists, capturing a fleeting moment of calm before the chaos. And to showcase the beauty and elegance of the architecture and design that is so often overlooked.

One of the hardest parts of this project – alongside the anxiety – has been the 3 a.m. starts at weekends while the city still slumbers on. This has often been a necessity in order to capture the serenity of a normally busy platform or escalator. There is a beauty rarely seen at this time of the morning. The city is sleeping, and I am witness to a moment that most people never see.

This project has tested my confidence as a photographer. I would describe myself as an introvert, so standing in front of strangers with a camera, as I often had to do, waiting for them to disappear, proved difficult. I do not like to draw attention to myself, and many trips into London for this project left me feeling incredibly vulnerable and uneasy. The extensive diary I have kept along with my photographic journey has helped me to record my thoughts and feelings about each shoot. I have left nothing unsaid and sharing some of these words in this book feels an important part of this five-year project. I have learnt that when it comes to coping with a lack of confidence and feelings of anxiety, it is important to remember we are not alone. Above all, it is helpful to find something that provides an escape and keeps the mind away from negativity. For me, that is photography.

This book is my personal photography journey capturing the history, beauty and tranquillity of an empty London Underground that is rarely seen by those who use it most.

Victoria Louise Howard
2018

Acknowledgements

Thank you to all my friends and family who have supported and encouraged me over the past five years to complete this project and publish. Without you, there wouldn't be a book.

And I can't forget to say thank you to my beautiful dog, Barnobee. You're a star.

Thank you all, from the bottom of my heart.

Victoria Louise Howard
2018

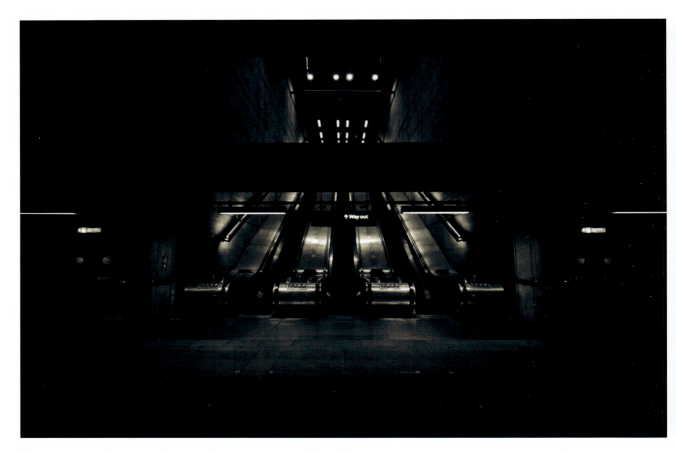

Bermondsey: Similar to Canary Wharf but opposite, I think this perspective looks far more interesting with the dark sky outside.

Photography Statement

Throughout this project, I have tried keeping my camera settings as constant as possible. This can prove to be very challenging depending on the lighting and weather conditions. The cameras I have used have been a Canon 7D and a 5D MKII, with a 24–105mm f4 L lens and a 50mm f1.8 lens. Where possible, I have kept the ISO values, shutter speed and F-stop the same. Some of the photographs therefore have more digital noise in them.

For editing, I have used Lightroom only. This has given me greater control over the finer details in each image. They were shot in RAW, and allowed me to be consistent throughout the project. I chose a split-tone edit because I wanted to create something slightly different than black and white, and more interesting and less distracting than colour. The blues and creams add a little more depth to each photograph and I have purposely underexposed to create an eeriness and unfamiliarity to the subject.

It was a very conscious decision to ensure there was symmetry in each photograph to further emphasise the notion of travelling through the image, as you would the Tube, drawing the viewer further into the photo.

To be able to photograph the platforms, escalators, stairs and carriages empty, I had to carefully plan each trip and the time of day I visited. Most were photographed early morning at the weekends, as this is the quietest time on the Tube. Midweek around lunchtime also proved to be quiet, patiently waiting for that brief moment when all was calm. Evenings proved to be tricky, as there was always at least one lone commuter waiting for the next train. Patience played a huge part in being able to complete this project. It also helped me to silence the anxiety for a while as I waited for people to leave the trains and platforms.

Tuesday 21 May 2013

Today is my first trip into London to capture the images for my university project. I have been planning this for a number of weeks after visiting in April to develop my ideas. The London Underground is being upgraded and these beautiful stations may be lost forever, so these photographs will offer a snapshot of what used to be. We are all too quick to modernise and not take in all the small details we walk past everyday, so maybe these photographs will encourage people to stop and take in the beauty of the Tube. I am incredibly nervous about today. I will need to try to be in control of my anxiety and take my time. Pace myself. Hopefully keeping a diary will help.

I am looking forward to photographing Gants Hill – it is such a beautiful and iconic station. Tottenham Court Road and Covent Garden are always busy, so it could prove to be difficult to photograph them empty. Other stations on the list are Marylebone, Bethnal Green, Hyde Park Corner and Regent's Park. I might try a few others as well, depending on how I feel.

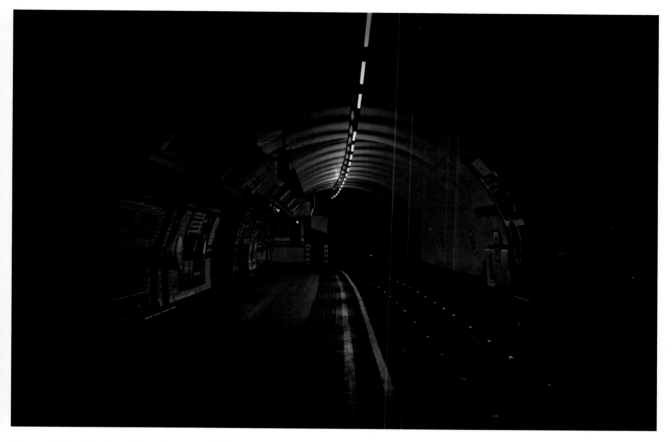

Regent's Park: One of my favourite platform photographs, I was surprised that it was empty when I got off the train.

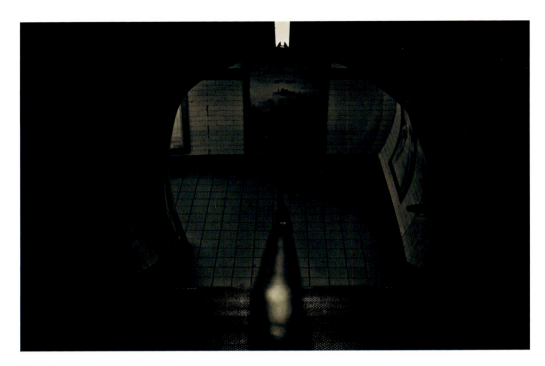

Marylebone

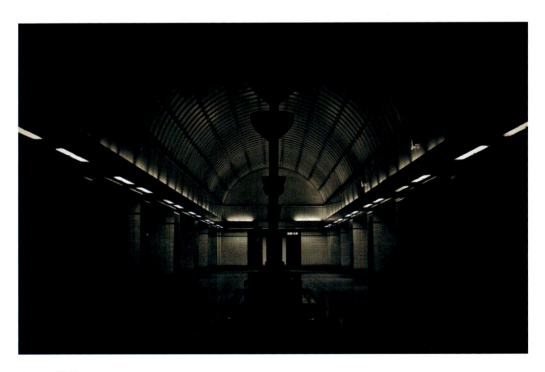

Gants Hill

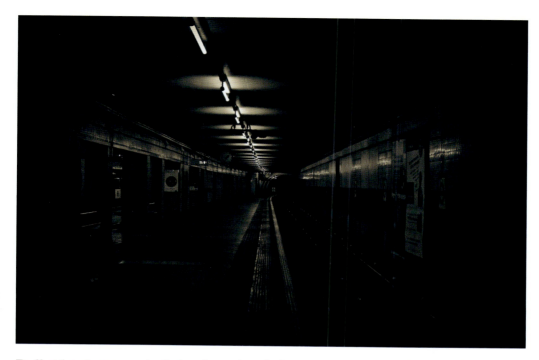

Redbridge: I was surprised when I saw this platform, as it wasn't the typical 'tube' shape. Beautiful all the same.

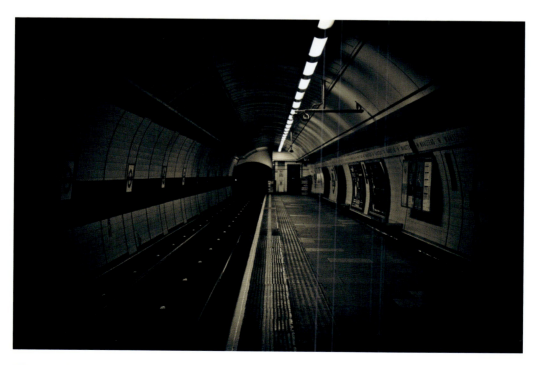

Wanstead

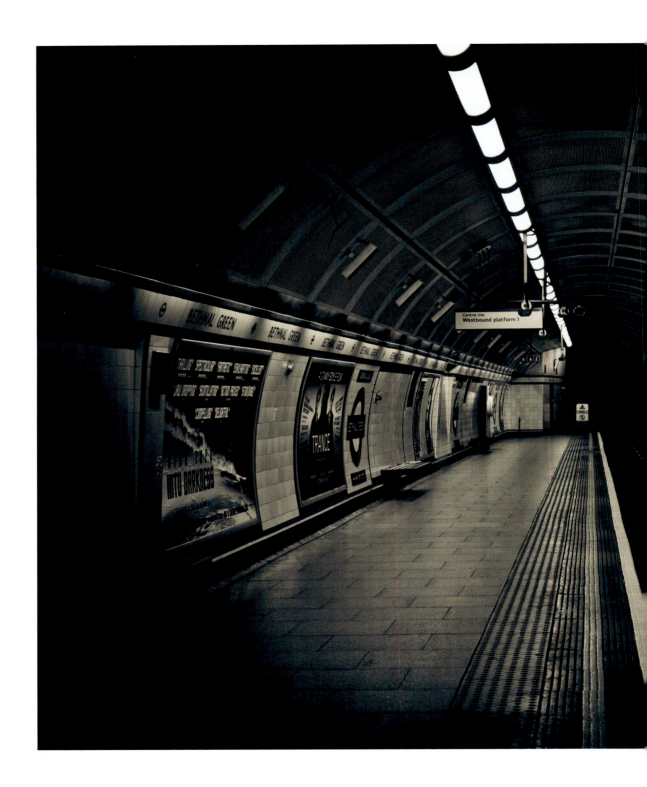

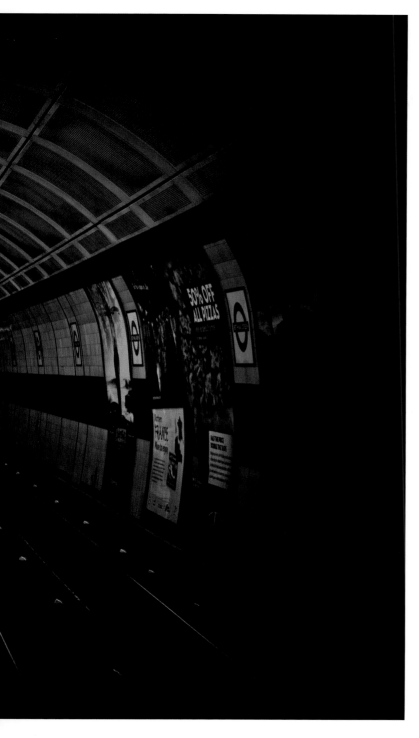

Bethnal Green

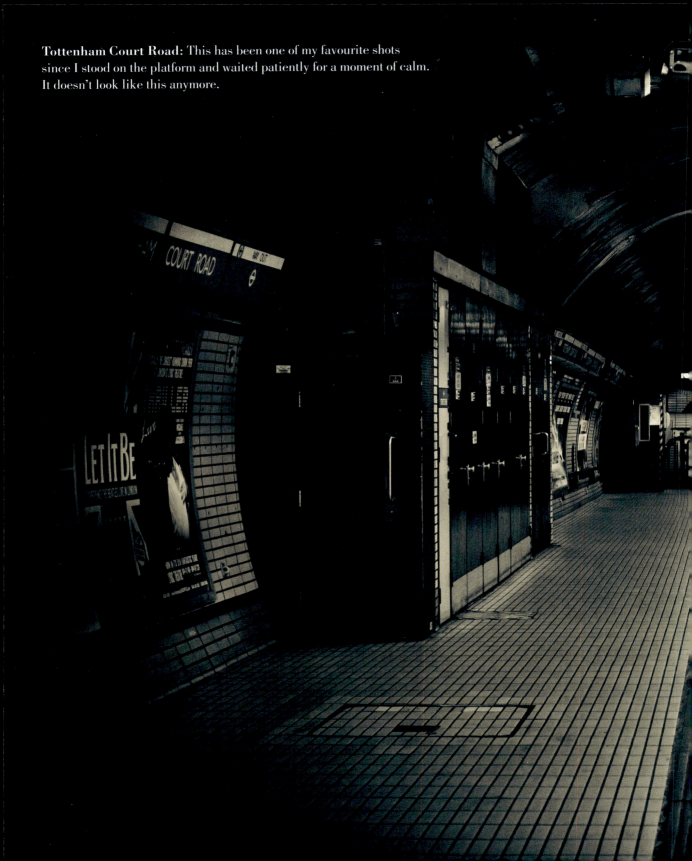

Tottenham Court Road: This has been one of my favourite shots since I stood on the platform and waited patiently for a moment of calm. It doesn't look like this anymore.

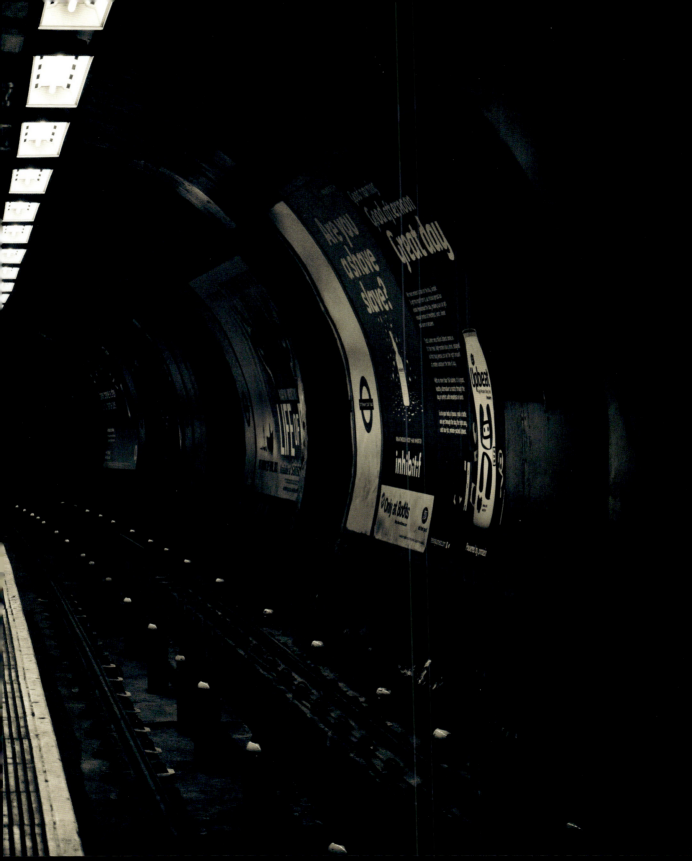

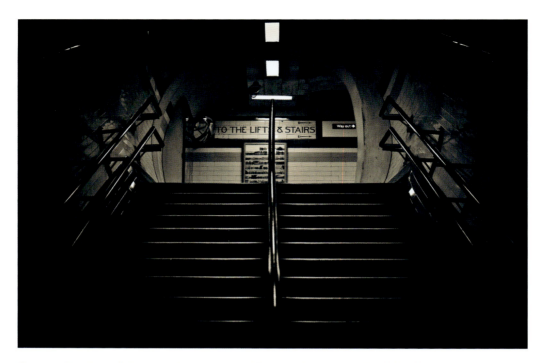

Covent Garden: This was taken on a busy Tuesday lunchtime, I only had seconds to capture these steps and make sure no one was reflected in the mirror.

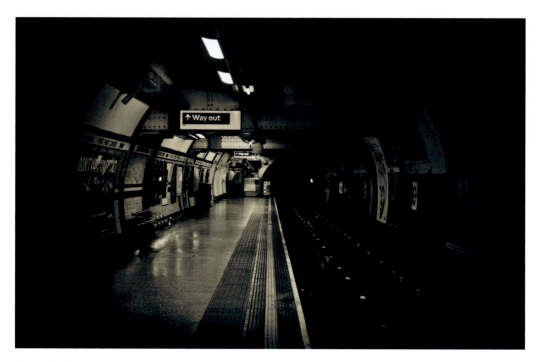

Hyde Park Corner

Saturday 19 March 2016

This is my first trip back into London to photograph the Tube in nearly three years. I am super nervous as it feels like a huge milestone after the surgery on my spine and lots of physiotherapy. The decision to continue photographing Tube stations has come about because I feel that I need a project to concentrate on, and I like having something to keep me occupied outside work.

Not sure how many Tube stations I will manage today or how busy it might be. Really want to visit Baker Street as it is from 1863 – one of the oldest parts of the Tube. Have to remember my settings from last time as I would like to keep some continuity to this project – ISO 800, F4 and use the 24–105 lens.

I do wonder if this is actually worth doing. Keeping the diary does feel weird, but writing down how I feel seems to help and makes the impending journey into London less daunting.

———•———

Not sure that was an overly successful trip … London was *busy*. Did manage to capture the empty interior of the Bakerloo line carriage and I love it. Why can't they always be empty? Baker Street was as busy as I thought it would be so patience was key. I had to wait for about half an hour but it was worth it. Maida Vale is a lovely station and pretty quiet, I took a shot from the bottom of the escalators. I recognized this station from the film *About Time*. And lastly, Southwark. Out of this world is the best way that I can describe this station. It is like something from the future – nothing like the stations I have photographed so far. The Jubilee line is very modern.

I am disappointed that I only managed these three today, but it is a start. As soon as it starts to get busy, I can feel myself getting more and more uncomfortable. I just want to close my eyes and go home. I wonder if it will always be like this.

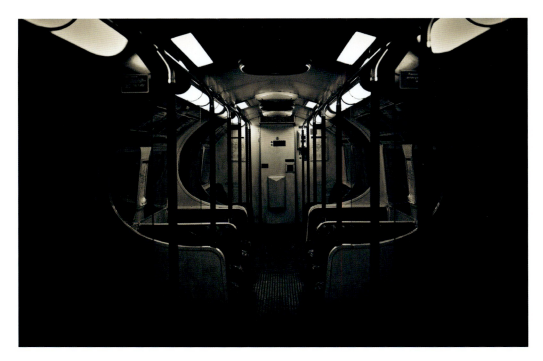

Bakerloo line carriage

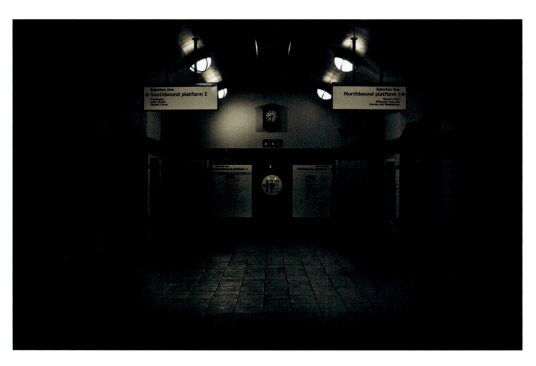

Maida Vale

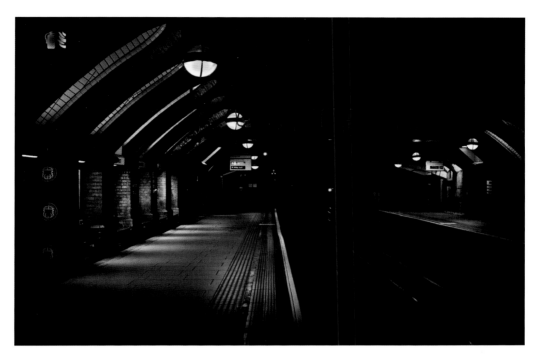

Baker Street: Despite waiting for the platforms to be empty for a split second to get the shot, it was a great place to people watch while I waited.

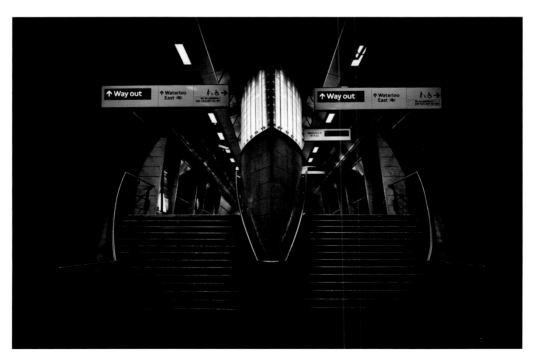

Southwark: When I saw this station, my first impression was that it looked like something from a sci-fi film. It was more modern than the stations I had visited before.

Friday 15 April 2016

Today it is raining heavily, this will make getting some of the shots I want very tricky. I'm going to drive towards Ealing and park somewhere around there so I can jump onto the Central line. That will make getting home easier if I start to panic. I've decided to try a lunchtime trip during the week, to see if any of the stations further outside central London are any quieter.

———•———

Wasn't the best trip – the rain was incredibly heavy and meant I had to hide under the platform covers instead of exploring the station. I was happy with the shot of the inside of the Central line carriage, as there were some newspapers left behind and the rain on the windows looked perfect. Only managed to capture two stations today.

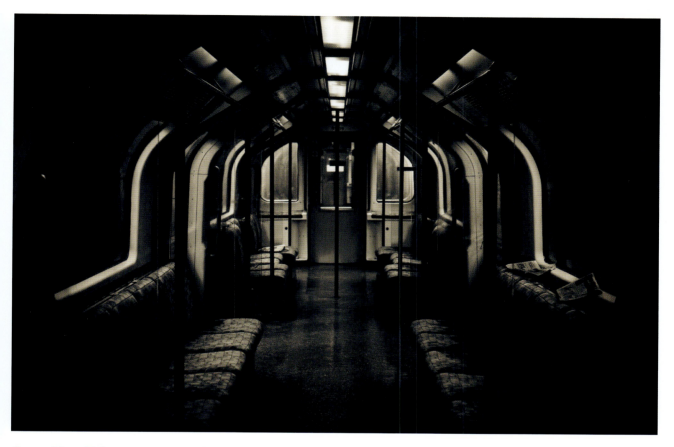

Central line Tube carriage: Another favourite empty carriage photo. I love the papers that have been left on the seat, it reinforces the presence of absence.

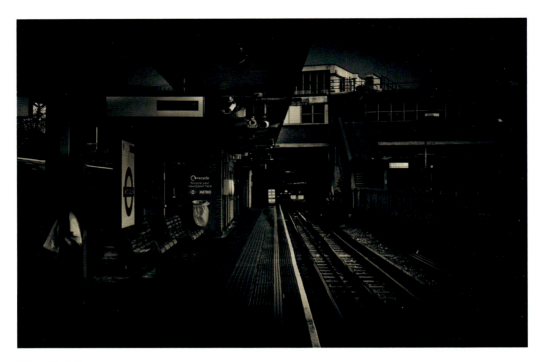

West Ruislip

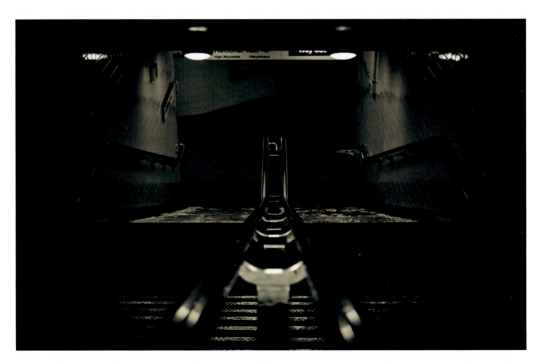

South Ruislip: I felt so lost at this station, it looked very bare and bleak. Combined with the horrible weather, I took a gamble on this photograph, and it worked.

Saturday 23 July 2016

For the first time I am going to get the first train into the city from my local station, which means I will have to get up at 4 a.m. – not looking forward to that. I have made a list of the stations I would like to shoot and, learning from last time, will not be disappointed if I don't get all the shots I want. It will be great if I manage to get Earl's Court station at least. It is one of the busiest stations on the network so might prove tricky. Would also like to get Westminster, as the stations on the Jubilee line look really futuristic.

———·———

Well, two out of ten stations isn't a disaster, but it feels like it. Earl's Court was super busy even at 6 a.m. on a Saturday, so I couldn't get the shot I wanted. Paddington, Bayswater and Notting Hill Gate were all too busy as well. Did manage to capture a great shot at Westminster station, although that place feels like a maze!

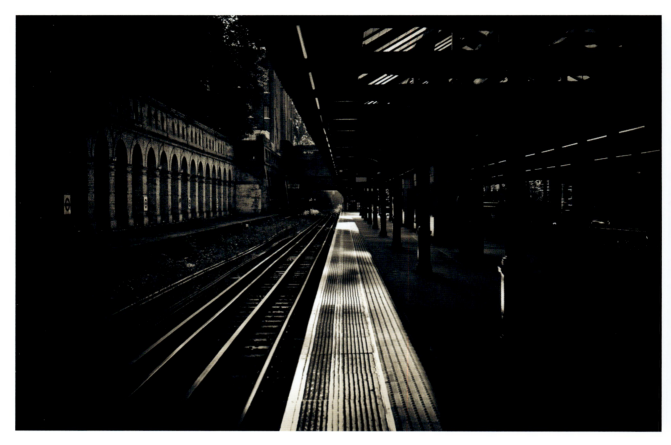

South Kensington: This will always be one of my most loved photographs A warm, hazy summer morning and it was peaceful and quiet at the station.

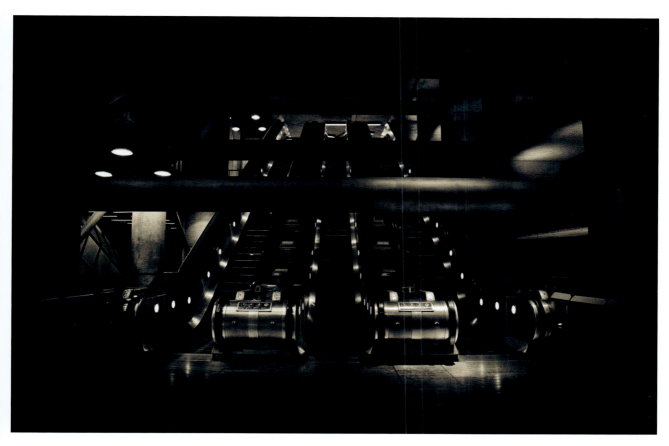

Westminster

Saturday 13 August 2016

Attempting another early-morning trip and will hopefully get to Earl's Court before the crowds descend … a 5 a.m. start from Ealing Broadway! Last time I was there, though it was busy it gave me time to have a good look around for a perspective I liked. There are two I will attempt. It would be great if I was able to capture Ealing Broadway as well, but I don't think I will have time to get both.

Going to visit quite a few more stations this morning as well. Looking at going on the Piccadilly line and capturing some of the stations on the way up to King's Cross and beyond. Would be great to get to Cockfosters!

Overall, not a great morning with my anxiety. I struggled a couple of times when it started to get busy and I felt quite ill. I had to sit down, zone out and try to calm myself down. The problem with having an episode like that is the fear of drawing attention to myself exacerbates the anxiety even further – and there isn't room to hide on a platform!

Photography wise, I am pleased with what I have achieved and now Earl's Court is done! I went with the second of the two shots and I am really happy, as it isn't the obvious choice. Couldn't get Ealing Broadway as I suspected, but I am not disappointed. King's Cross was also far too busy to be able to get a shot, and the station is huge! I wouldn't know what shot would be best. Cockfosters and Oakwood are great stations, but these will need to be photographed at night, purely because I feel it would give a better atmosphere to the shot. The other stations I photographed this morning I am happy with – now time to edit.

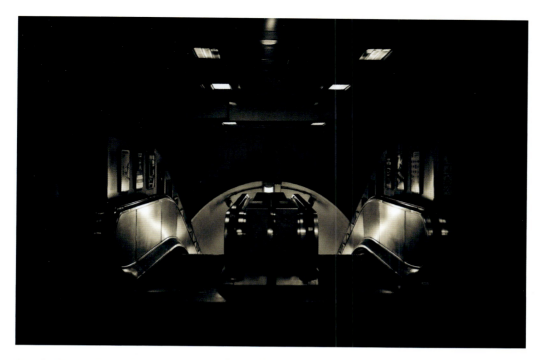

Earl's Court: I love this photograph. I thought about shooting the platform and tried it, but this perspective had so much more appeal.

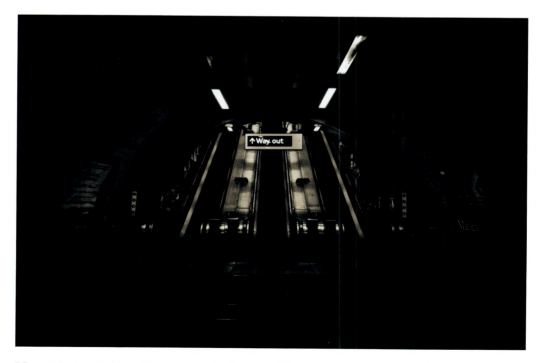

Manor House: The architecture at the bottom of the escalators was too good to pass up, though I had to wait patiently for a moment of calm. The nerves and fear were setting in.

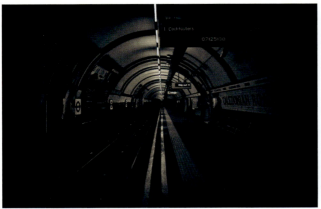

Caledonian Road

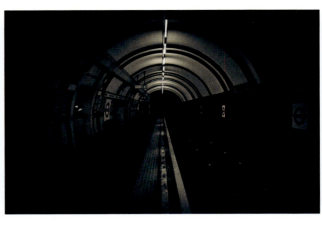

Holloway Road

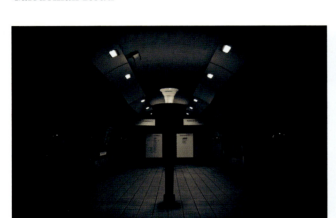

Turnpike Lane

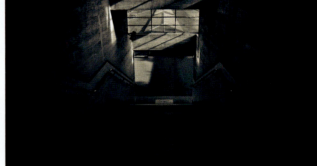

Arnos Grove

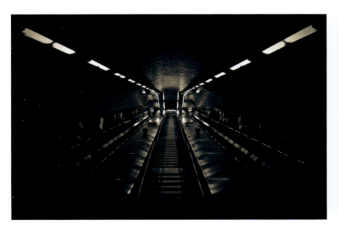

Bounds Green

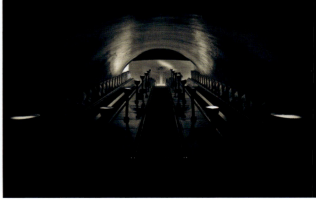

Southgate

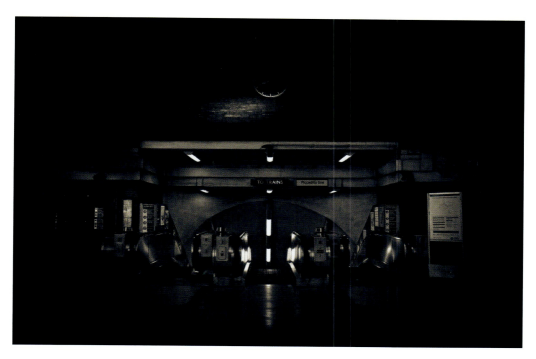

Wood Green: This was a very difficult photo to get as it was in the ticket hall which was full of people. I felt so self-conscious that I nearly didn't go through with it.

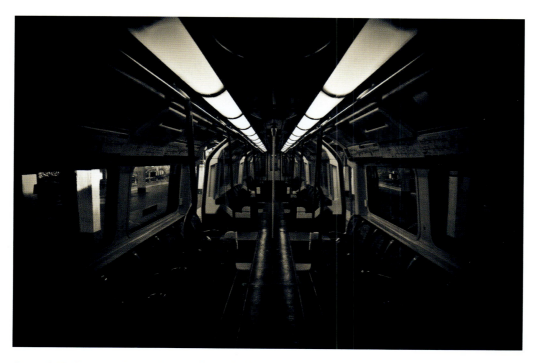

Piccadilly line carriage: It was a breath of fresh air when the stations and carriages became quiet again. If only they always looked like this.

Sunday 9 October 2016

Northern line is on the list this morning. And on a Sunday. I have made a list of the stations I would like to photograph this morning and the kind of image I'd like to get at each station. This might be a good idea, or might put more pressure on myself, we'll see.

I am trying to get more confident every time I go into London and travel on the Tube, but I'm not sure if I am actually helping myself. I can feel myself getting really wound up and anxious writing this and I haven't even started yet (I tend to write these the night before I go, as a way to prepare myself). Writing down my feelings *does* help. Although, in another way, writing them down makes them feel real and validates them. I don't know what to do.

———•———

This was definitely not a great trip. Managed to get a couple of shots that I am happy with, especially the one at Camden Town. Also captured Warren Street, Mornington Crescent and Charing Cross. The rest was a washout – or at least I was. I had a panic attack while I waited at Waterloo to come home. It wasn't triggered by a huge amount of crowds, as it was fairly quiet. I just felt incredibly overwhelmed and I think that what I wrote down last night was true – I had put too much pressure on myself.

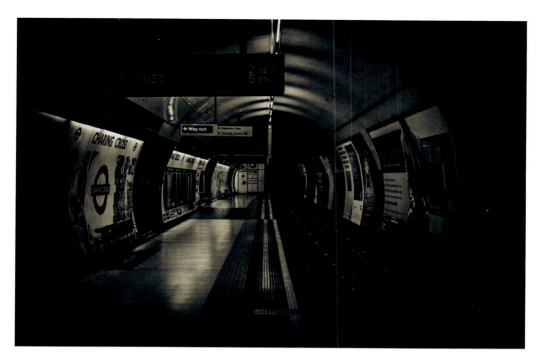

Charing Cross

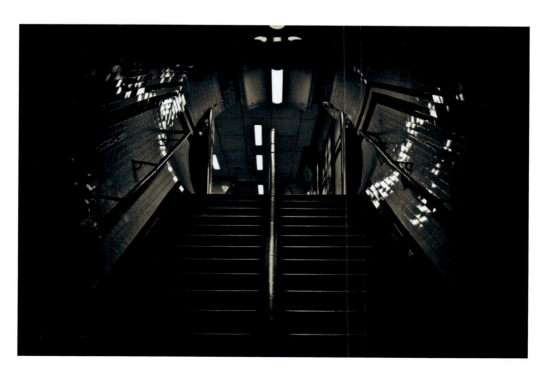

Warren Street

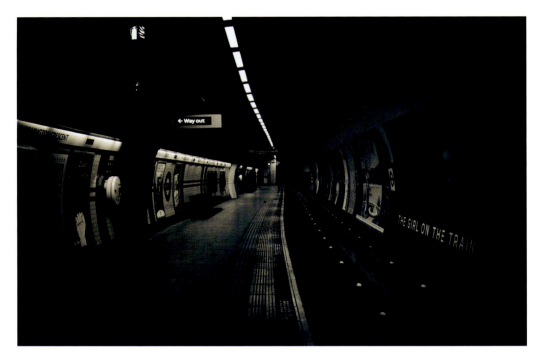

Mornington Crescent

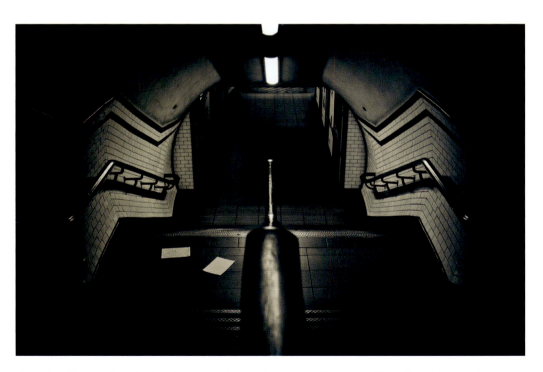

Camden Town: Despite having a tough morning, remembering taking this photograph puts a smile on my face. I felt so lucky seeing those papers on the stairs and I still do.

Saturday 10 December 2016

This is my first trip for nearly two months – the last one really took it out of me and, honestly, I was scared to go back into London. I needed a break for a while. This morning is a good excuse to get some photographs before meeting a friend for some Christmas shopping on Oxford Street. Although, if anything, the busy crowds in the stores are guaranteed to make me panic instead of the Tube this morning!

 I have made myself a list of the stations I would like to visit, but not what photographs I am going to try to get. That way, I can go at my own pace and take time to look around. There are only a few on the list so I am in no way pressured.

—◦—

This seems to have been a much better trip than before. I felt relaxed because it was very early and it was quiet. Old Street and Hampstead are beautiful stations. I am really happy with the images from these stations. I enjoyed exploring London Bridge and Canada Water – although when I went outside at Canada Water I thought I was going to freeze! Bank station was a nightmare – it's a maze full of people. North Greenwich was similar. It is very inconvenient when people actually want to use public transport … in my ideal world it would always be empty!

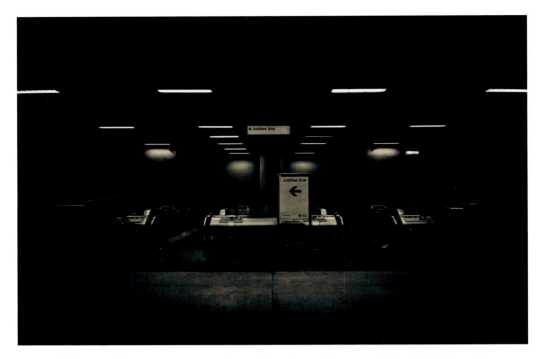

Canada Water: This was a surprise shot and one I wasn't sure would work. I changed my mind when I edited this photograph. Now, it's a favourite!

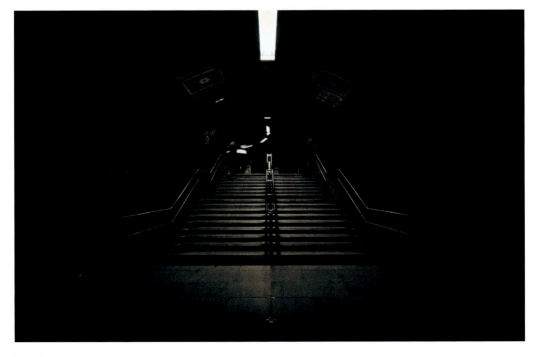

London Bridge

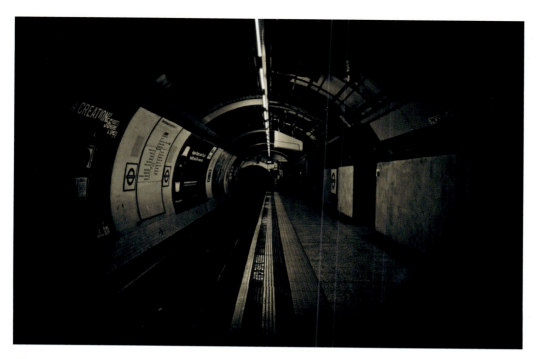

Moorgate

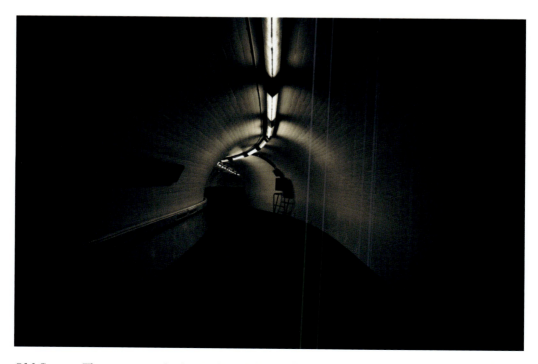

Old Street: The name speaks for itself and the winding tunnels feel full of history. I nearly got lost down here.

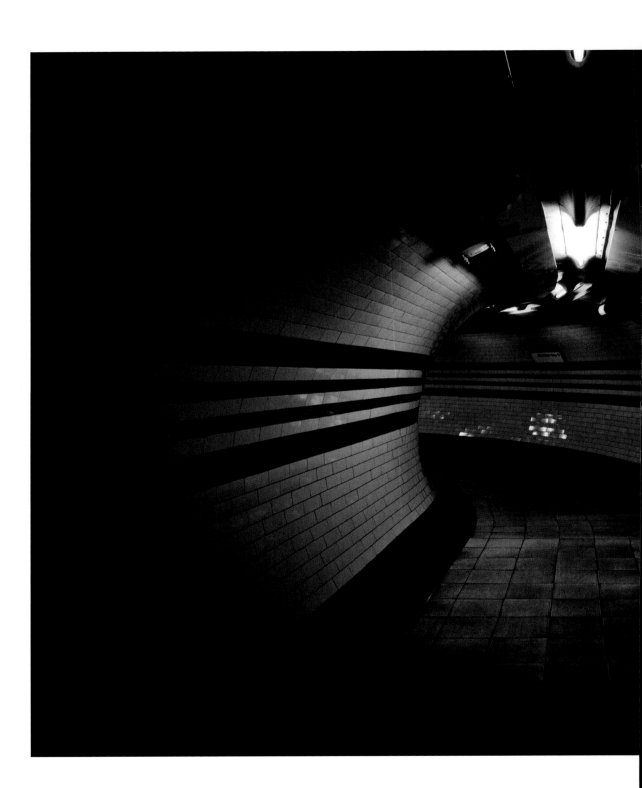

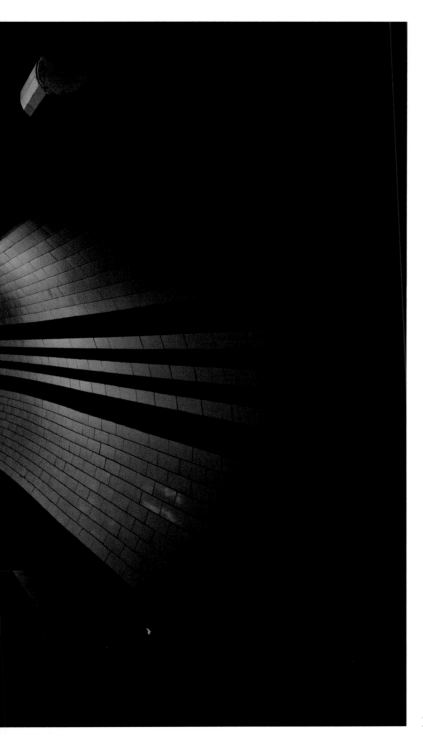

Hampstead

Saturday 31 December 2016

Well, it is the last time this year I will go into London. I am very excited to stay and watch the fireworks. A few friends have told me that some of the busiest stations on the network are quiet in the afternoon on New Year's Eve, so I am going to give it a try. It would be great to photograph Bank station – if I don't get lost – and explore some others along the way.

———•———

Bank was empty! And I actually saw a couple of other photographers capturing the same shot I was after, so great minds think alike. I am pretty chuffed with it, I can't imagine many people get to see this part of the station without a single soul in it. The other stations I captured were St Paul's and Lancaster Gate. I know it isn't a lot, but I am happy with the trip. It was a positive note at the end of a rollercoaster year.

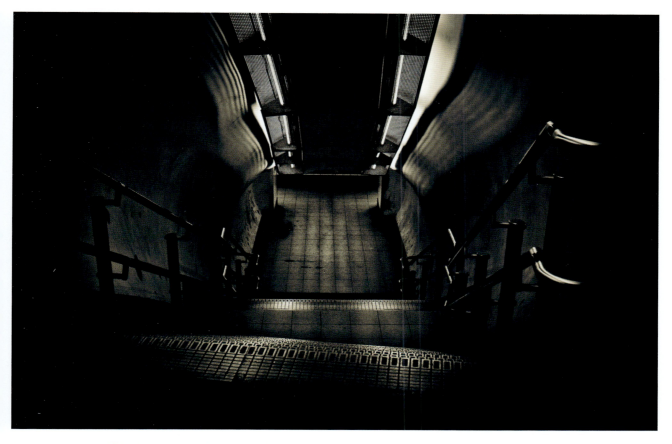

Lancaster Gate: The lines and angles in this photograph make it look disjointed, but out of all the shots I could've taken here, this one was too much fun to overlook.

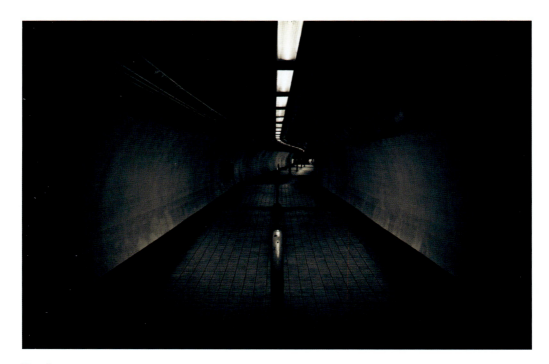

Bank

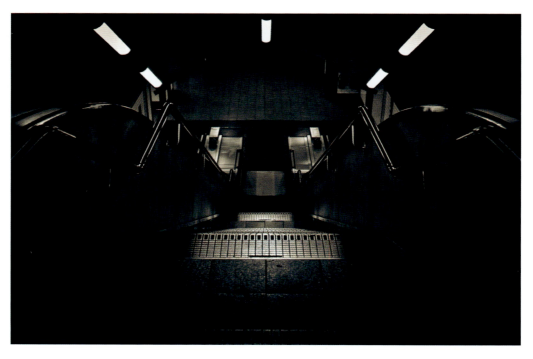

St Paul's

Tuesday 10 January 2017

I wasn't actually planning on taking any photos of stations today. I was in London for another reason but happened to have my camera with me. When I got to Embankment station, the beautiful staircase was empty at the perfect moment. I couldn't resist the shot and then of course had to write about it when I came home.

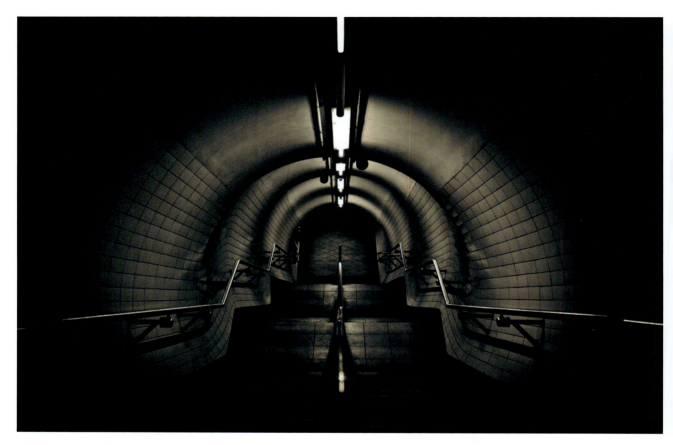

Embankment: I felt so lucky to have stumbled across this staircase, it looked so beautiful.

Saturday 14 January 2017

Today I am going into town to see an exhibition with a friend, but I can't pass up an opportunity to take my camera and take some snaps at a few stations. I have found that by planning days out in London, and fitting in some stations before, it really helps with my anxiety as I have something else to focus on. Cannot say that it is going to work each time, but it seems to be a great start.

I would really love to be able to capture Canary Wharf this morning. It has to be one of the most iconic stations on the network and photographed by many, so I appreciate that my shot will not be unique. But it will still be a big step for me, something I can be proud of.

———◦———

And … I did it! Canary Wharf is in the bag, despite being very busy today. I had to wait a long time for this one, and sometimes the waiting is tough as it gives me too much time to think about my anxiety. However, I persevered and captured the shot I wanted, I'm proud of myself. Managed to capture a couple of other stations too – Waterloo and Monument. Had to have help with the Monument station though, without my friend I probably would have got lost and still be down there now!

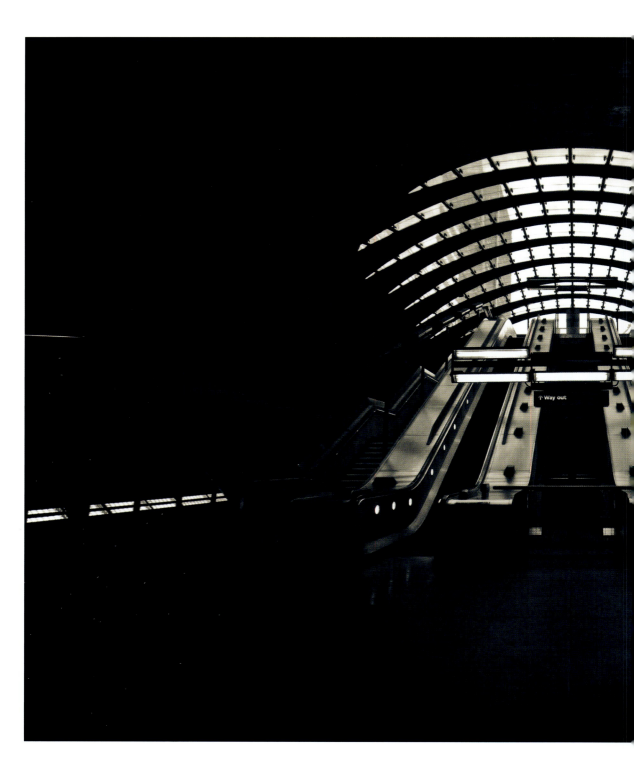

Canary Wharf: After trying this photo in the dark and failing, I had to return when it was busier to get the light. It was worth the wait.

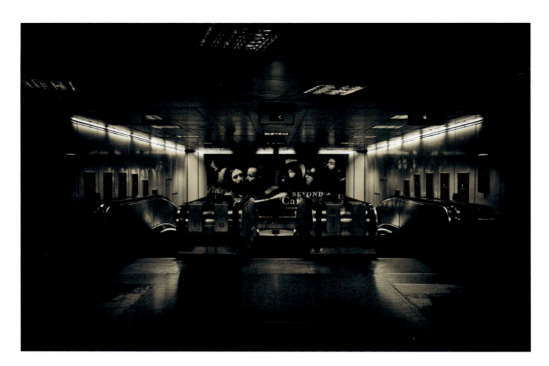

Waterloo

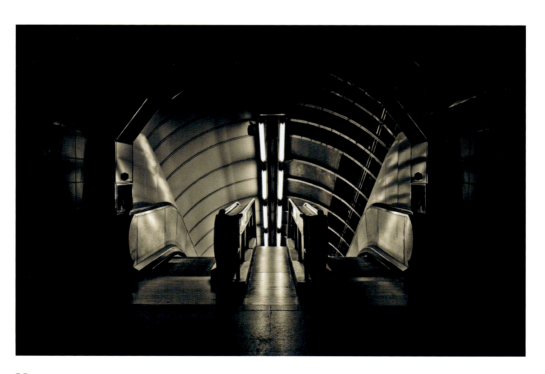

Monument

Side Note: Tuesday 24 January 2017

The doctors have said there might be another issue with my spine, so I will have to limit my activities and walking etc. It is rather upsetting and gutting, but I have to keep going. Still, it gives me more time to edit and focus on other things.

Saturday 1 April 2017

My first trip into London after not being able to do much for a couple of months. Rather nervous for two reasons. Firstly, I am hoping that my back will be strong enough and that I can manage a few hours without being in pain. Secondly, I hope that my anxiety issues won't creep in as well. I have a few stations on my list for this morning, but am still making sure that I take my time so I do not feel overwhelmed.

Pretty great morning to start with, considering what has happened. I took my time, didn't pressure myself and made sure I kept myself calm. Can't say I know how I did this, but it certainly felt good. Visiting some of the stations in the dark was definitely worth it; I think the results will look great. A few stations were far too busy and I didn't manage to get any decent shots – Liverpool Street being one of them. I genuinely think that station is never empty!

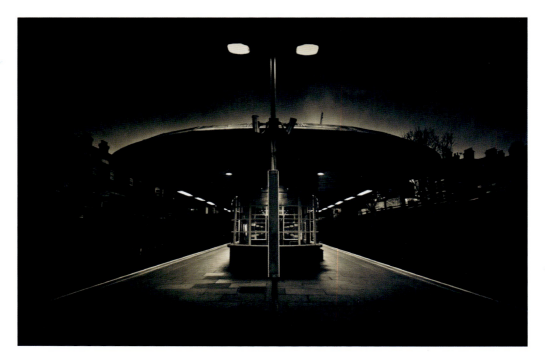

West Hampstead

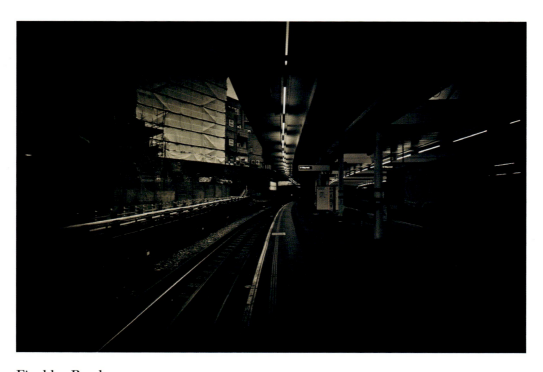

Finchley Road

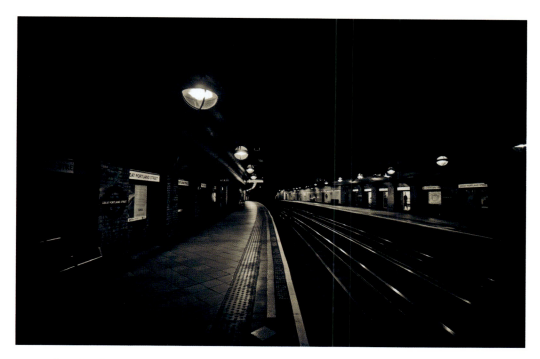

Great Portland Street

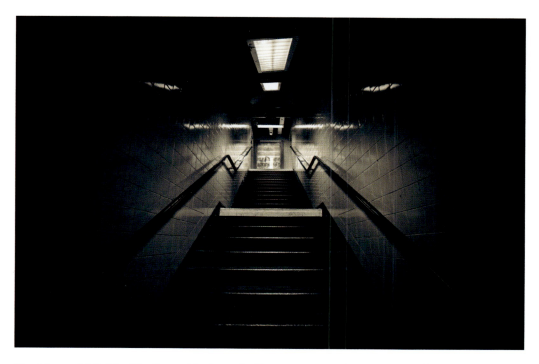

Barbican: I felt like I had stumbled on a hidden gem when I stepped onto the platform here. This project has been full of surprises.

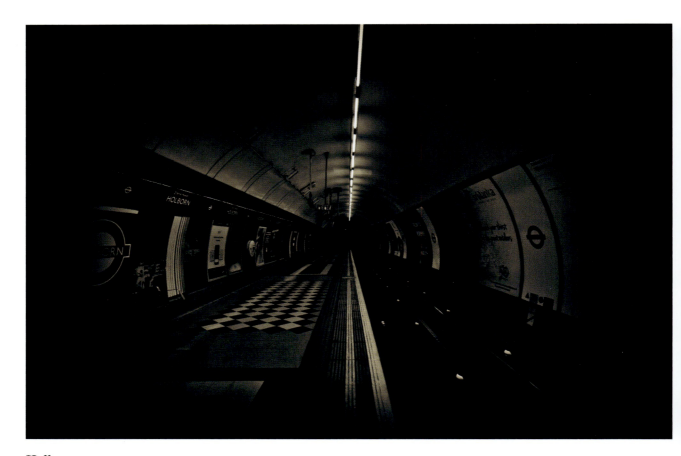

Holborn

Saturday 15 April 2017

I am excited for this morning as I am headed to Liverpool Street again. I figure I am going to have a long wait for this one but it will be worth it. The other stations on the list are pretty busy ones too. Oxford Circus is going to prove tricky, but not sure what type of shot I would like here. I have quite a few on the list for the Central line, north of Stratford.

In reality it was far too busy – I tried, though. I am pleased with myself because I waited for over an hour to get a photo of the platform at Liverpool Street. It felt very stressful waiting and I was unsettled, but pushing through those issues was worth it. I am so happy with the shot and the curve on the platform is beautiful. A lot of the other stations were too busy at that time of the morning for me to be able to take a shot that I would be happy with. When I think about it, the more time I have to explore a station, even if it is busy, the better the outcome when I go back. And it also means that I should be more relaxed when I re-visit that station.

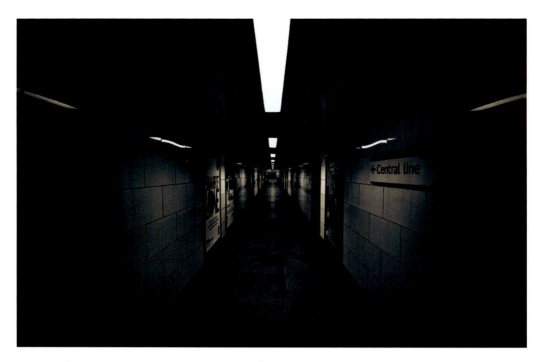

Oxford Circus: I was very surprised to capture this photograph, I thought the station was going to be full of people.

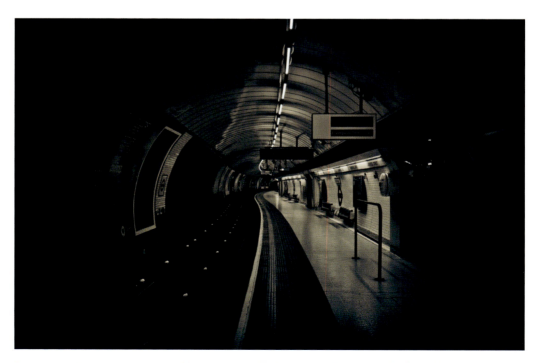

Liverpool Street: I was incredibly happy with this photo. It was worth all of the previous unsuccessful visits and patience. It felt like it was never going to be empty.

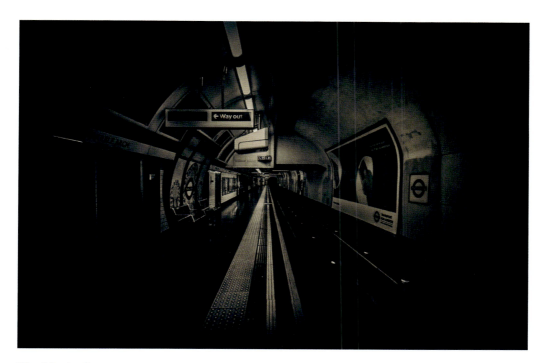

Marble Arch

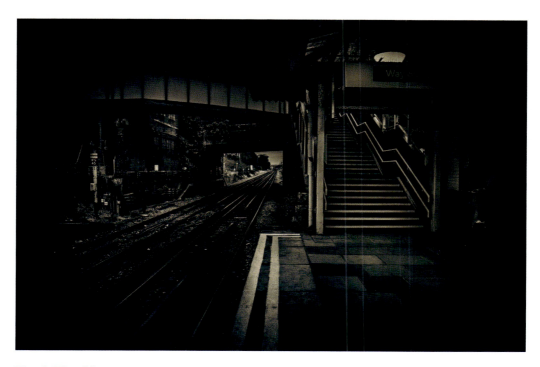

North Wembley

Monday 1 May 2017

I am going to visit some Northern line stations this morning. I am hopeful that it will be fairly quiet as I am going south of the river and catching the first train in. Although it is very hard getting up in the middle of the night to travel into London early, I find that I enjoy that time of the morning. It is so peaceful and quiet, the sunrises are beautiful and, for a brief moment, London is all mine. Focusing on these positives helps to overcome the anxiousness. Today should be a good day.

———•———

It was! I managed to photograph a lot of stations this morning and captured the inside of an empty Victoria line carriage. Brixton was far too busy, as end of the line stations tend to be. Oval is a beautiful station but, again, it was busy. Happy with the stations I did managed to capture and it felt calm, as they were pretty quiet. The symmetry in some of these stations was stunning and I felt I could have taken hundreds of photos. No anxiety today – a first I think. Feels great to be able to write that down. The train journey in from home was peaceful and the sunrise was spectacular. The majority of the stations were quiet and the photography felt good. Really looking forward to editing the pictures.

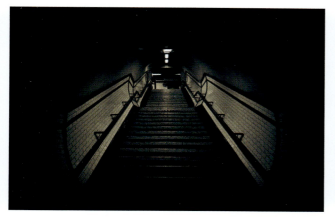

Kennington

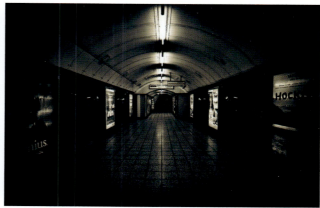

Stockwell

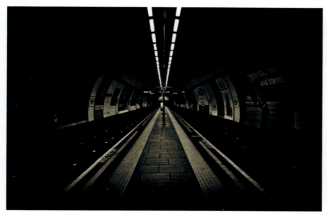

Clapham Common

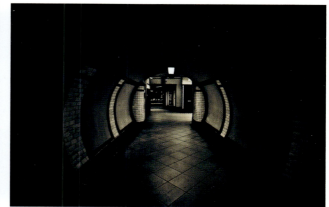

Clapham South

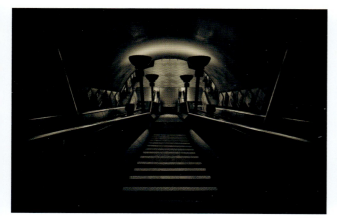

Balham

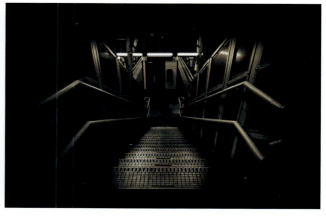

Morden

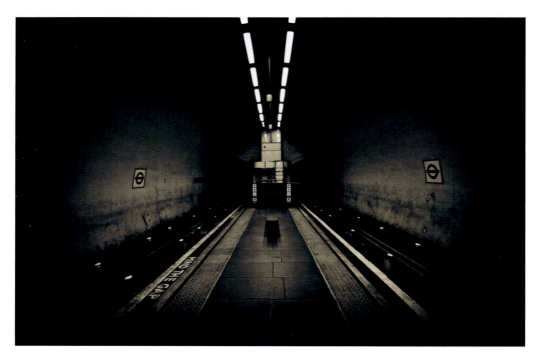

Clapham North: An unusual double platform with beautiful symmetry.

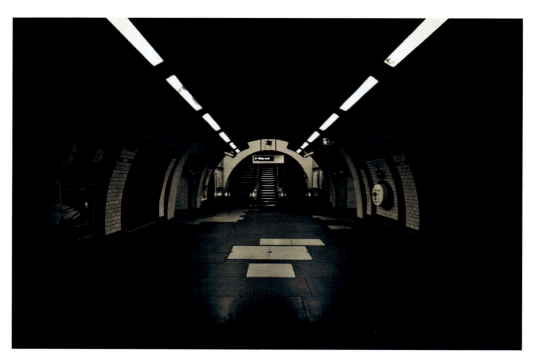

South Wimbledon: These replaced floor tiles are so eye-catching and a great contrast to the original tiles.

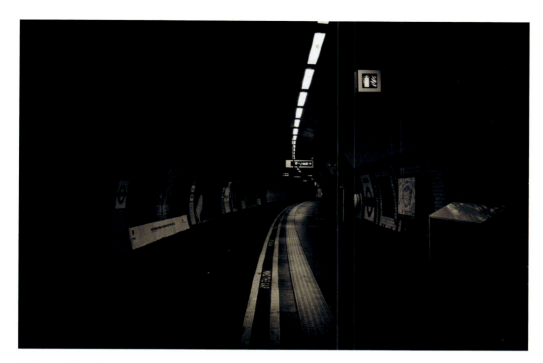

Colliers Wood

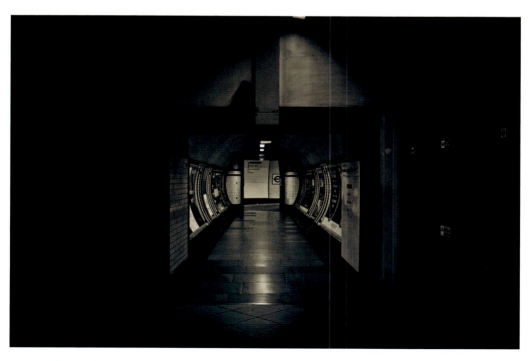

Tooting Broadway

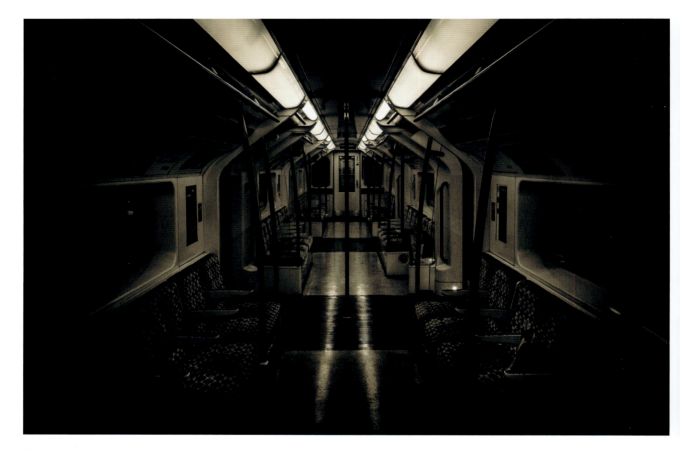

Victoria line carriage: There is something about an empty carriage that looks so unfamiliar.

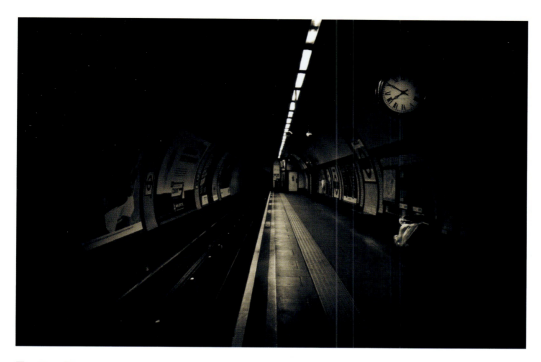

Tooting Bec

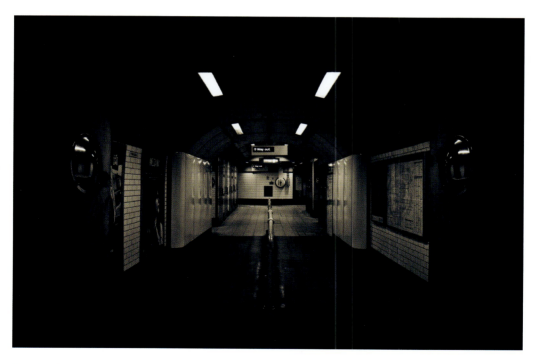

Borough

Saturday 2 September 2017

This is my first trip back into London after three months, which, in all honesty, have been tough. This morning feels daunting and already I feel very anxious. Being away from London over the summer couldn't be helped, but time away from perusing this project/journey really takes me back a few steps and has a negative impact. Honestly, it makes me want to give up.

Going to have a trip along the Victoria line this morning and try to capture quite a few stations. Just going to ensure that I take my time and have plenty of music to listen to along the way.

Well … it wasn't a complete disaster but wasn't the best trip either. It was a very busy morning, which meant a lot of hanging around and waiting for a moment when the station was empty. Unfortunately, this made me overthink the situation and my confidence was drained. I just wish that I could switch off the part of my brain that makes me over-analyse every detail. It is exhausting trying to cope. I think I managed three stations this morning and the photographs should be OK. Not sure that I want to go back to London for a while …

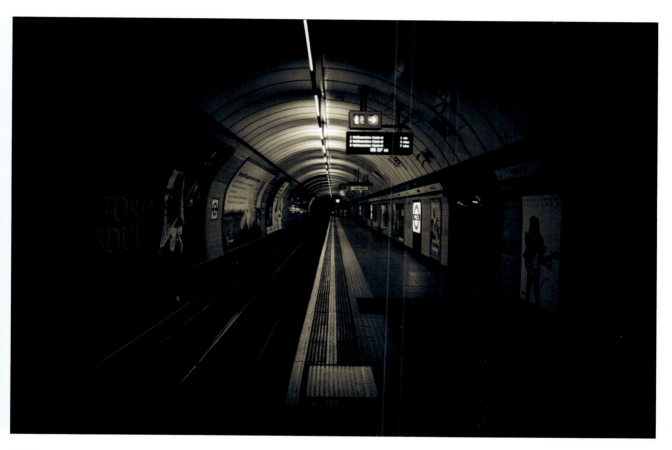

Pimlico

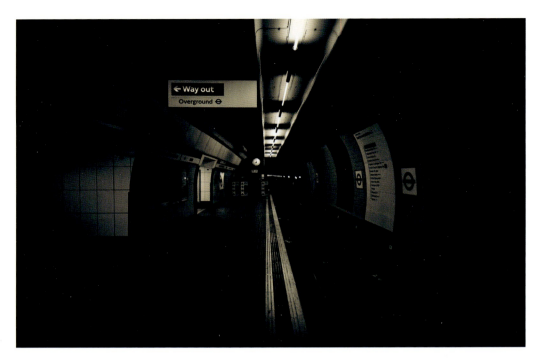

Walthamstow Central

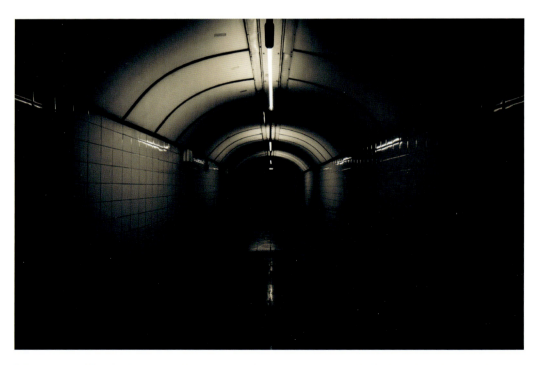

Blackhorse Road: One of the few stations that gave me an eerie feeling, that feeling of not knowing what lies in store.

Saturday 13 January 2018

My first trip of the New Year and I don't have to go alone. Really looking forward to having the company and the support. The last trip into London was a bit of a disaster so this morning should be great. I have quite a few stations on the list for this morning, a number of which are normally very busy. We are starting from a different station which means we can get into London even earlier and therefore will have more time to capture empty stations.

———•———

Having company made a massive difference. I still had a few moments when it became so busy that I panicked a little, but having someone there to hold my hand meant the world to me. I didn't feel isolated or alone because I had someone there who would look after me. This also meant that I captured a lot more stations than I predicted. I can't wait to edit the pictures and see what treasures I have found.

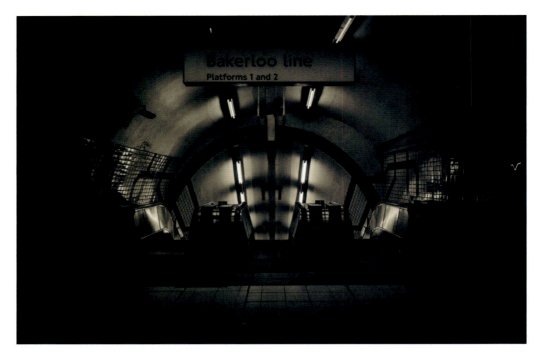

Piccadilly Circus: I look back at this photo and I felt so happy at the time, but now it makes me sad. Not everything lasts forever.

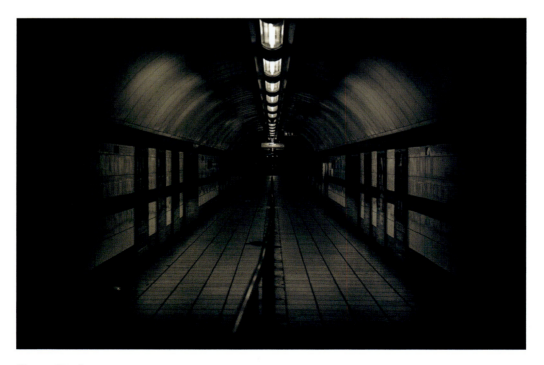

Green Park

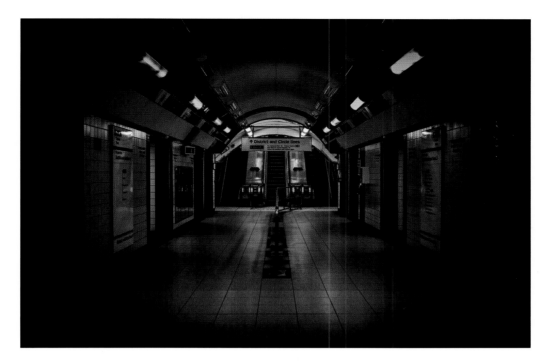

Victoria

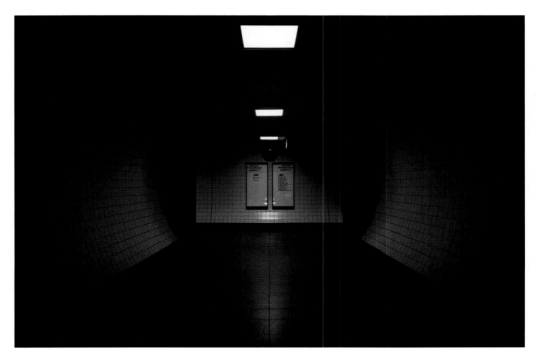

Vauxhall: Another eerie and beautiful station. I love the simplicity.

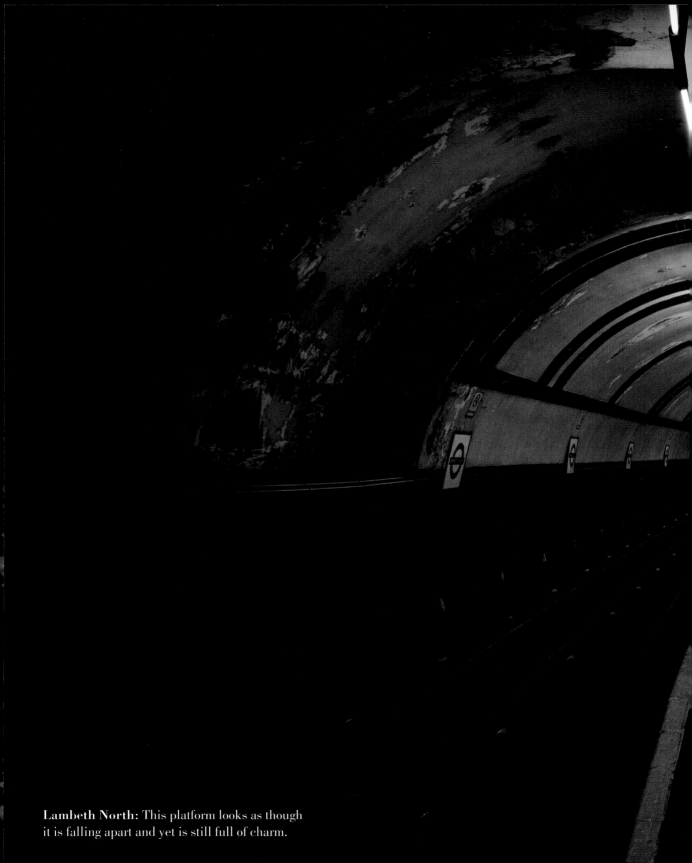

Lambeth North: This platform looks as though
it is falling apart and yet is still full of charm.

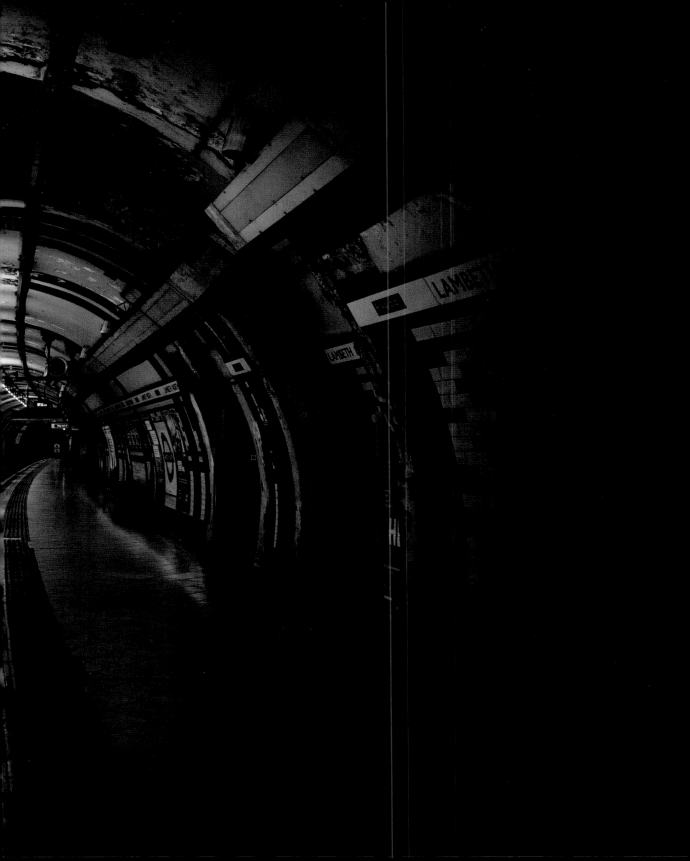

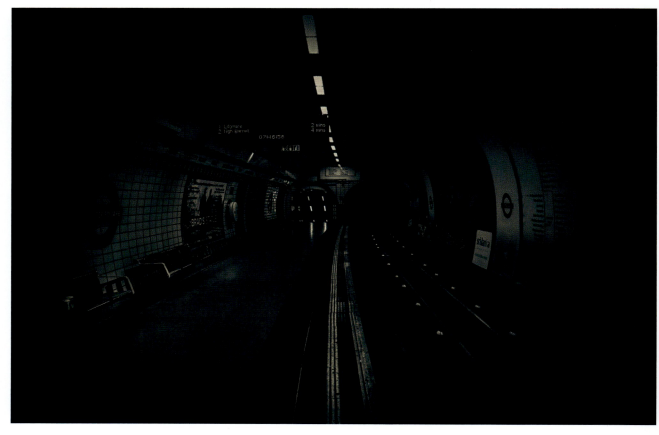

Leicester Square: The two abandoned cups on the bench in this photograph tell a story without a happy ending.

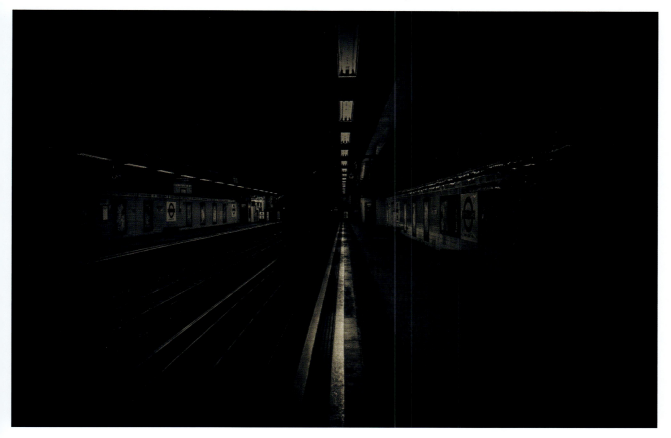

Euston Square: Such a stark and bleak looking platform, it felt like it went on for miles. I think it is beautiful.

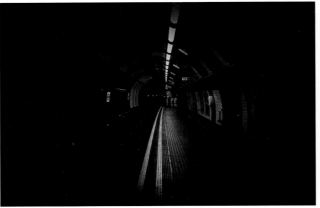

Brixton

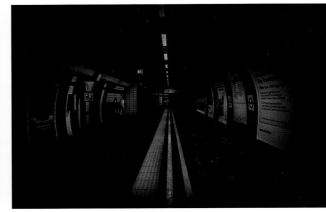

Goodge Street

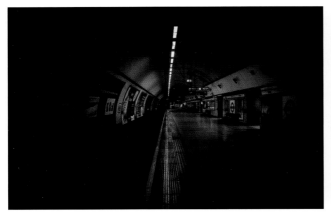

Euston

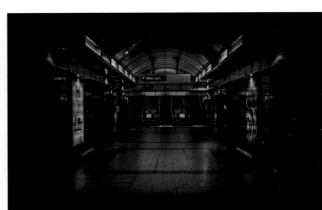

Angel

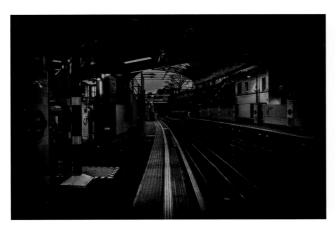

Farringdon

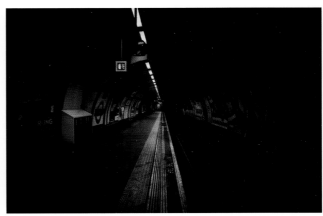

Oval

Saturday 10 February 2018

Not looking forward to going into town this morning – I am writing this the night before and the forecasted temperature for tomorrow morning is freezing! I would like to get as many stations completed as possible on the Bakerloo line, hopeful that they will be quiet. There are a few stations on the network that are technically two stations, Edgware Road being one of them. The goal is to photograph both the Bakerloo and the District and Circle branches this morning.

———— ◦ ————

The cold got to me this morning, it was –3°C and the majority of the stations were overground. Standing around waiting for the moment I could photograph meant that I was frozen from head to toe. Quite a few of the stations were pretty busy with commuters heading into London for work etc. I'm happy that I was able to shoot both branches of Edgware Road – a positive tick off the list. The rest of the stations will have to wait until it is a little bit warmer.

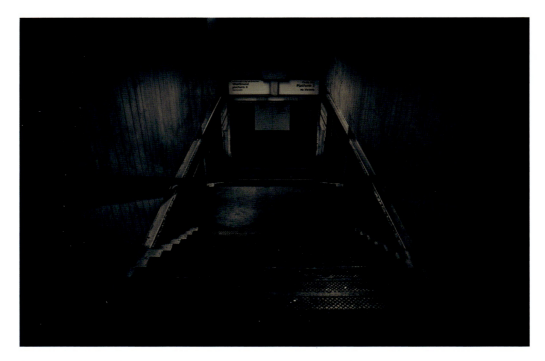

Edgware Road (District and Circle): I can still remember how cold it was standing at the top of these stairs.

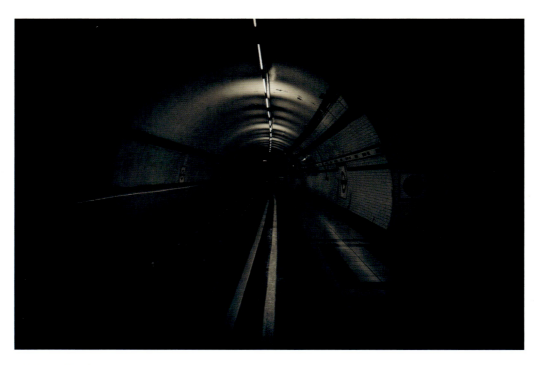

Kilburn Park

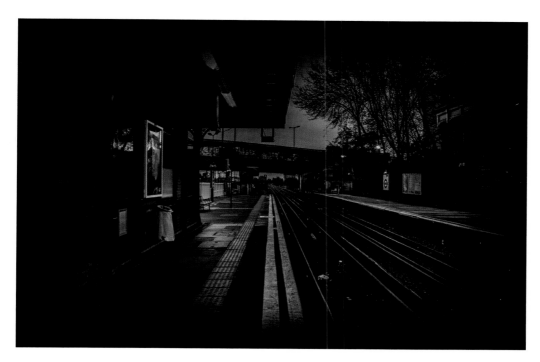

Harrow and Wealdstone: It felt like this station was never going to be empty!
End of the line stations are tricky like that and I felt so cold and lonely.

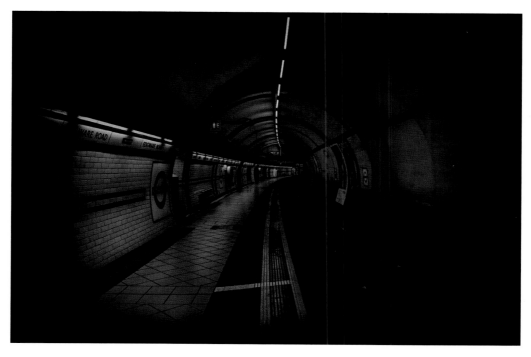

Edgware Road (Bakerloo): I absolutely love this photograph, it feels very typical of the underground.

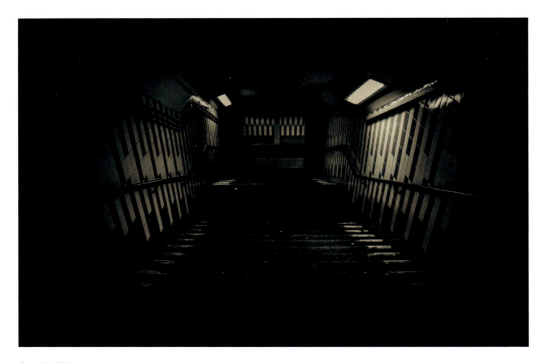

South Kenton

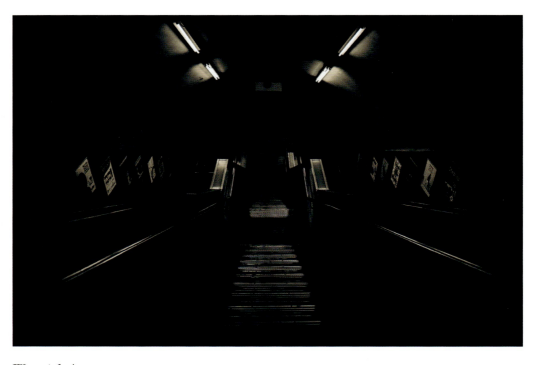

Warwick Avenue

Saturday 24 February 2018

Hoping for a slightly warmer morning – I have a long list of stations for this trip. A lot of these stations I have never visited before, so don't know what type of photograph I will be looking for. Not sure how positive I feel, I know I will not sleep well, but I am going out after I take my pictures and that gives me something to look forward to.

It's an odd feeling as this project is really starting to take shape, and in my photographs I can see the ups and downs that have come with it. I thought that by now my anxiety issues about crowds and busy lines etc. would be getting better, but I still feel as though I'm not in control when I go into London. That is the overwhelming feeling I have – that I am not in control of my own situation and it sets off an all-consuming panic. Will I ever get over this? I question myself all the time.

———•———

This visit was a mammoth effort and it exhausted me completely. I felt vulnerable when I got to Hammersmith station and had to walk across the road to get to the other station (Hammersmith is two different stations serving different lines). It was very early, still dark and there were lots of crowds about. With everything that happens in London, I guess it is only natural to feel unsettled when alone at this time. The other stations I photographed were all pretty quiet and I was able to get some beautiful photographs.

The whole time I kept thinking about the project and wondering if it is really worth it. Am I putting myself through all this for no reason? I don't know what I expect is going to happen. The dream is a book, but the reality is that I don't think I can keep going. I don't know what to do.

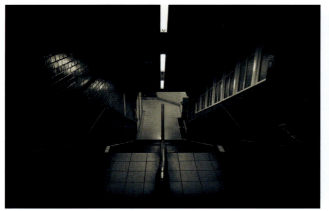

Ladbroke Grove

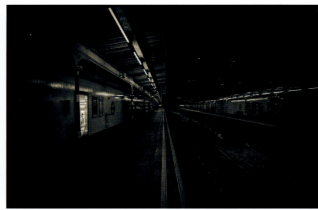

Latimer Road

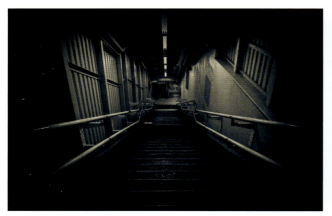

Shepherd's Bush Market

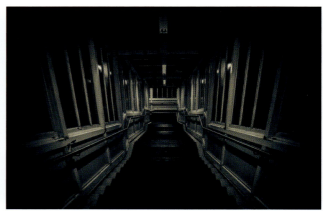

Goldhawk Road

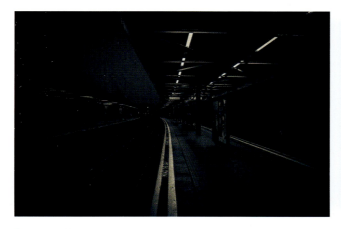

Barons Court

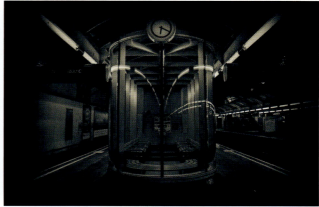

Hammersmith (District and Piccadilly)

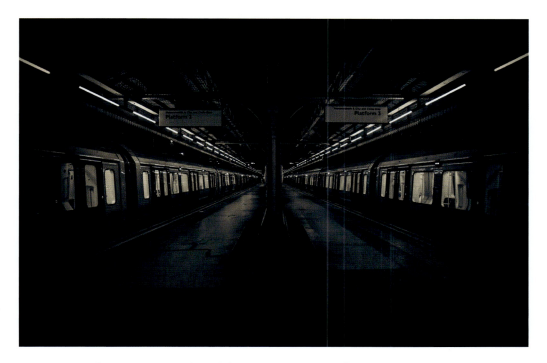

Hammersmith (Hammersmith and City and Circle): Both Hammersmith stations are beautiful to photograph, but as a young woman with a large camera and a nervous disposition, I felt very exposed and vulnerable here.

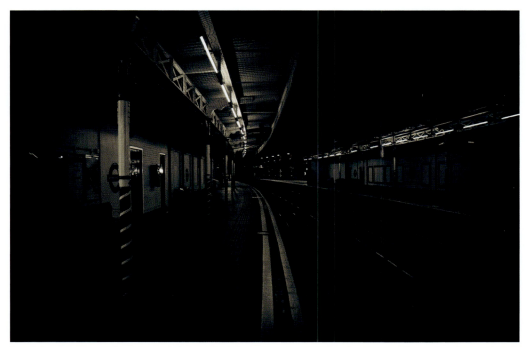

Westbourne Park: I struggled here and it was only the first station. I just wanted to go home.

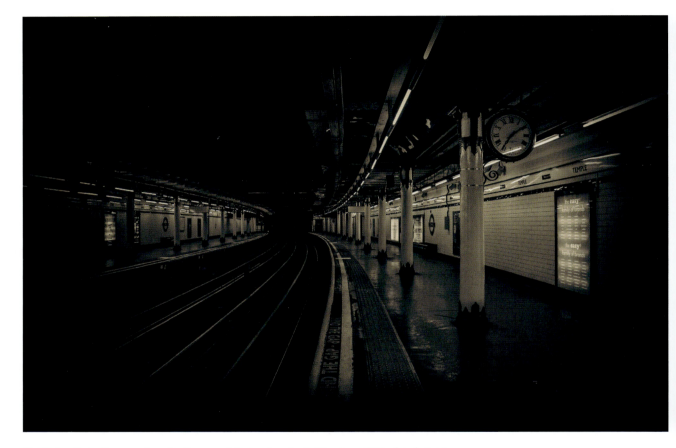

Temple: Standing on the platform at this station feels like travelling back in time.

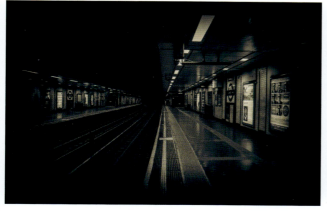

St James's Park

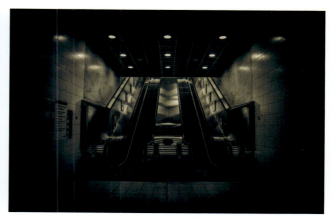

Blackfriars

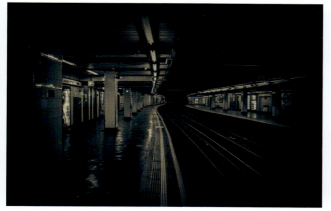

Cannon Street

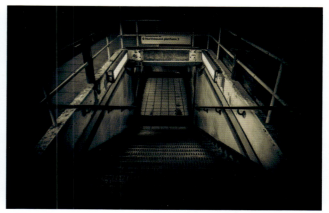

Whitechapel

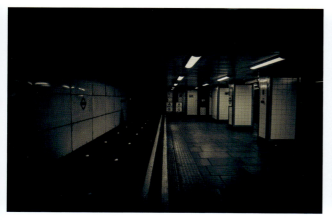

Mile End

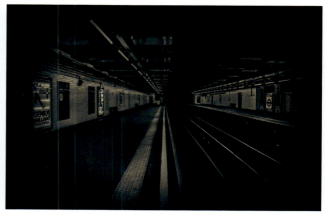

Stepney Green

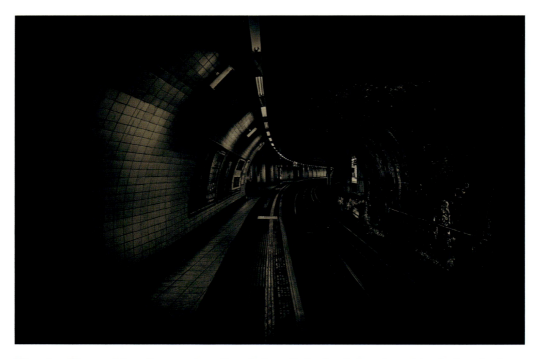

Mansion House: Literally, a station of two halves. I absolutely love how this platform looks.

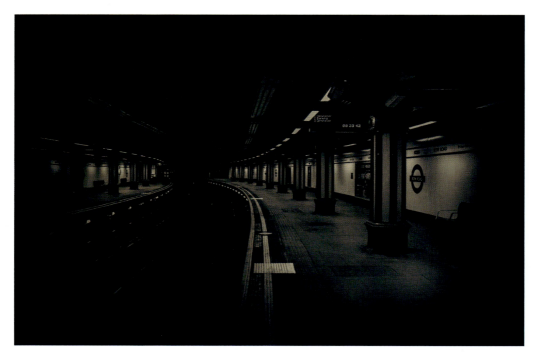

Bow Road: To me, this platform almost felt like a stage and it looked a little bit like one too.

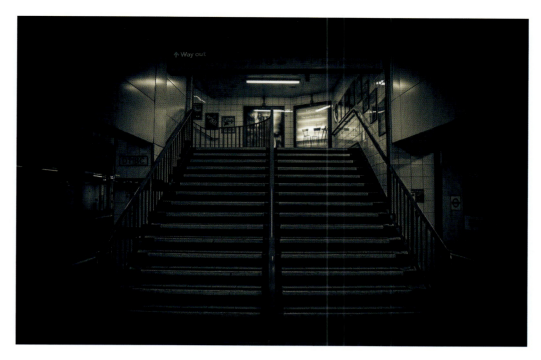

Tower Hill

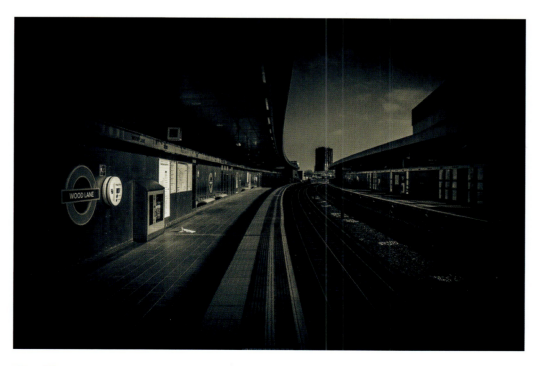

Wood Lane

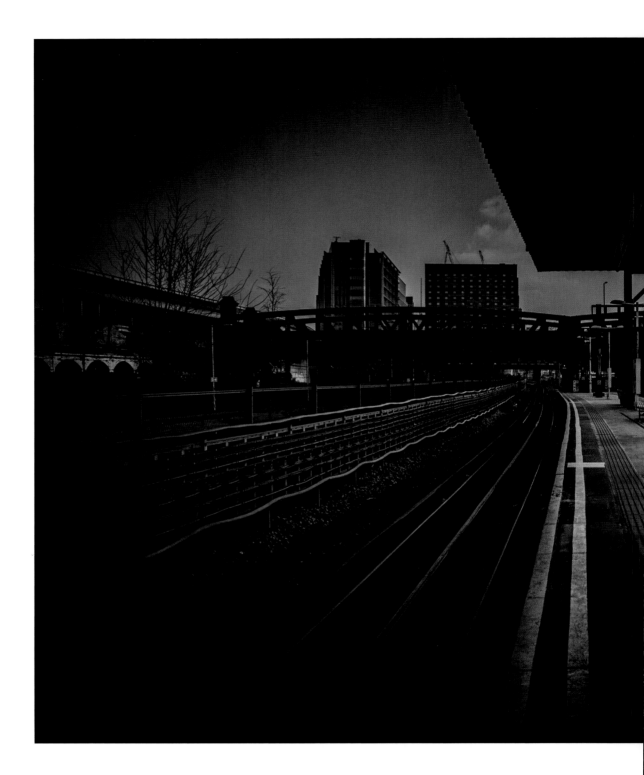

Royal Oak

Sunday 8 April 2018

So, in the morning it is supposed to rain – really heavily (again, writing this the night before). I have been waiting for these conditions for such a long time because there is one station I really want to photograph in the rain – Paddington. This station is classed as two, Bishops Road and Praed Street. The photograph I would like to capture is of the District and Circle line platform – I think it is a beautiful platform.

———•———

It felt like a productive trip, even though I ended up soaked to the skin. Paddington was beautiful in the rain. Pretty chuffed with the other shots I captured this morning. For a Sunday morning it was busy, even more than I thought it would be in the rain.

Recently I had been feeling pretty rough about going into London and trying to push myself to overcome my fear. I have come to the realisation that I am never going to get over something that has been with me for over a decade, and to try to think that I can get past it is unrealistic. The best I can do is try to finish visiting every Tube station and be proud of what I have achieved. Take it step by step.

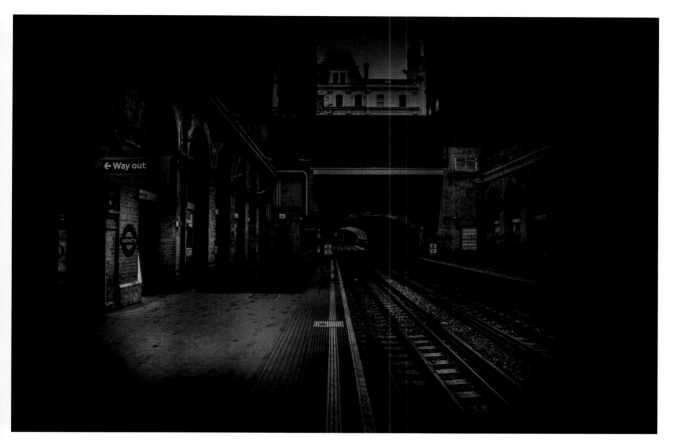

Paddington (Praed Street): After all those months of waiting, the rain came. This photograph was worth the many frustrating months of dry weekend mornings.

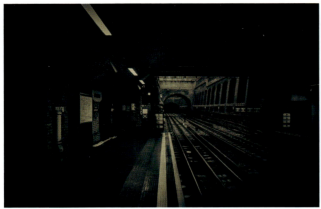

Bayswater

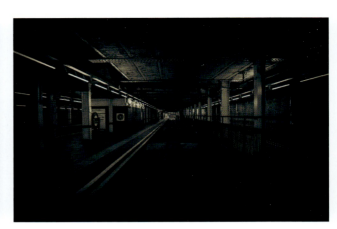

High Street Kensington

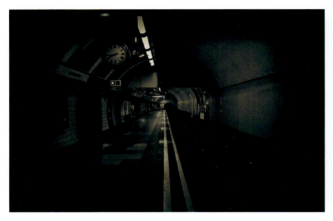

Queensway

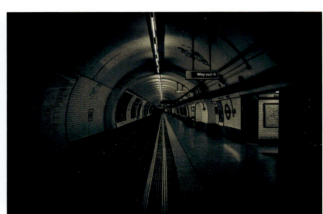

Chancery Lane

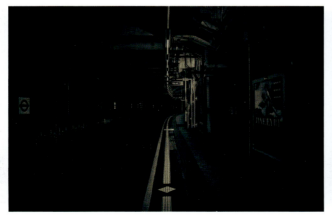

Aldgate

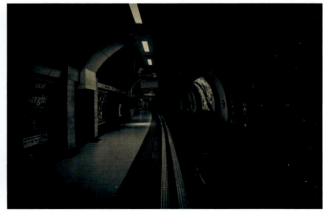

Knightsbridge

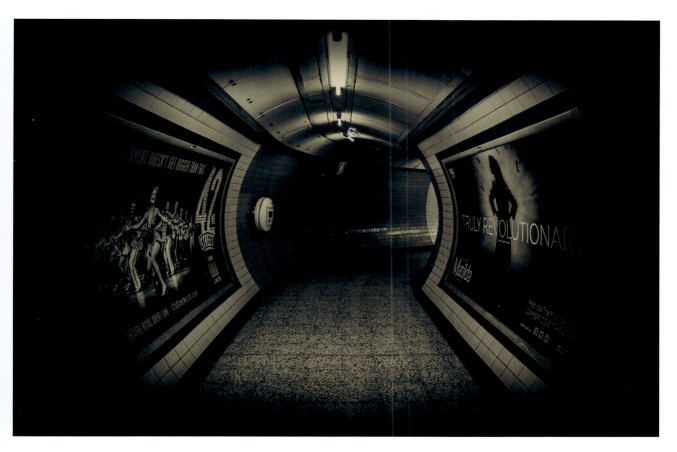

Bond Street: I had tried photographing this station once before, but it was too busy. I hate it when the station is busy. This photograph captures a lucky few seconds of calm.

28 April 2018

This was a very impromptu photograph taken at Highgate station. My mum, friend and I went to do the Parkland Walk from Highgate to Finsbury Park, and it was fantastic! And when we got to Highgate, it was empty so I took the opportunity to tick it off the list.

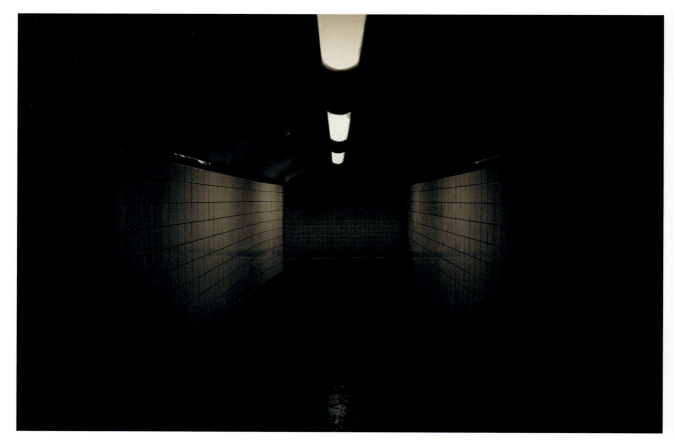

Highgate: This will always will be a favourite station for me in a beautiful part of London.

Monday 28 May 2018

Currently I am sat, drinking a pint of beer, in a pub by Tottenham Court Road. Today I am meeting a friend for a catch up, so the trip this morning was very last minute – literally as I was getting into bed last night I thought I would take my camera and grab the first train on a Bank Holiday Monday.

I haven't wanted to come into London for a few weeks because going through a break-up really takes it out of you and it has been pretty rough. It has been a journey of mixed emotions, but I made it through. I am pleased with all of the photographs I captured and I look forward to editing them. I even managed to tackle a couple of stations that have been annoying me for a while.

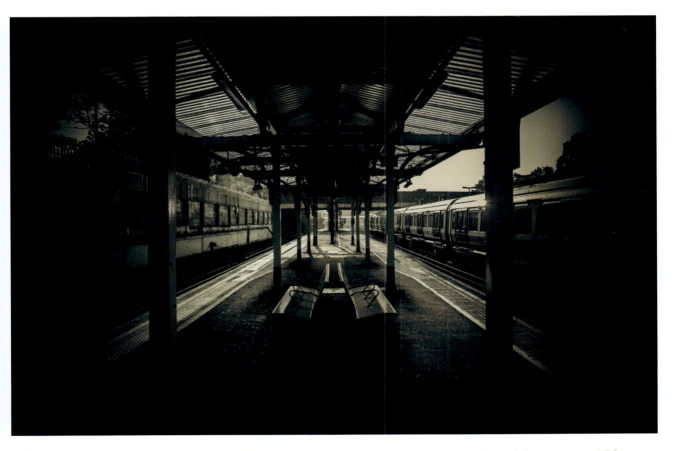

Richmond: I remember just sitting here for a while taking it all in. It was warm and calm and for a moment I felt at peace with the world. Such a beautiful platform too.

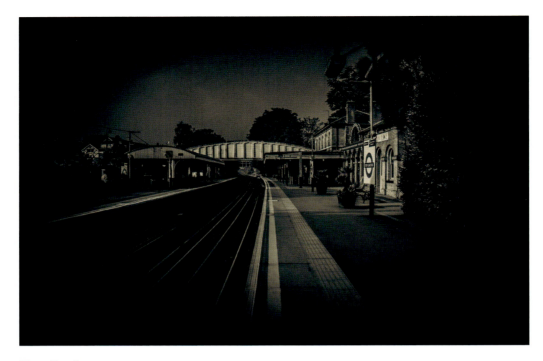

Kew Gardens

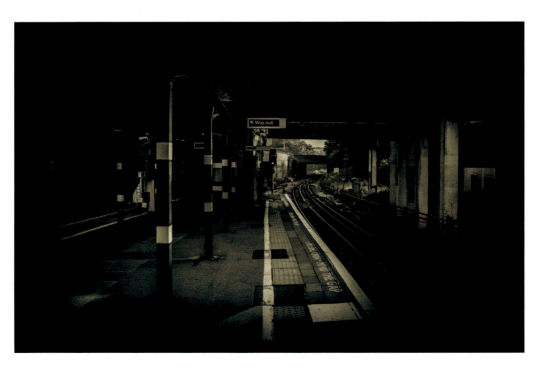

Gunnersbury

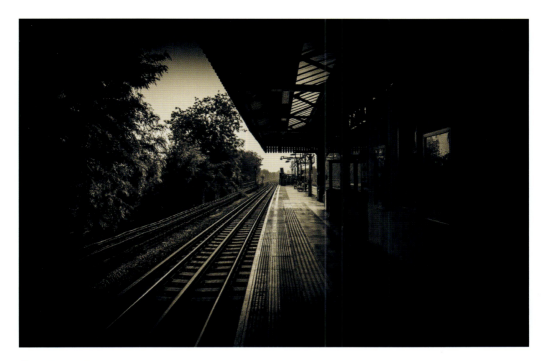

Turnham Green

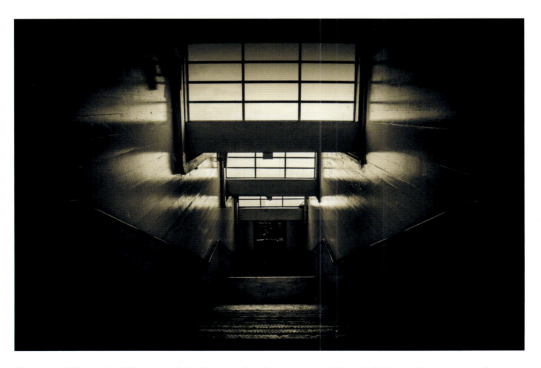

Stamford Brook: When the light hits perfectly and everything falls into place, even when everything else feels like it's falling apart.

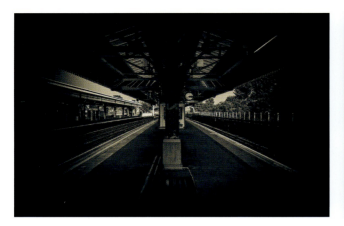

Ravenscourt Park

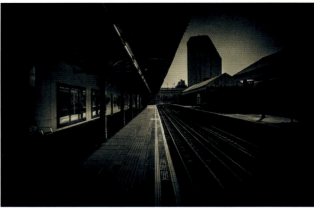

West Kensington

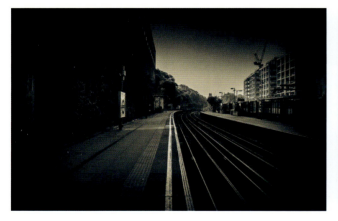

West Brompton

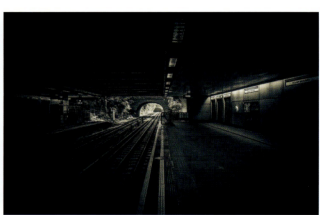

Fulham Broadway

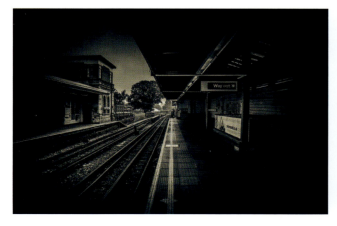

Parsons Green

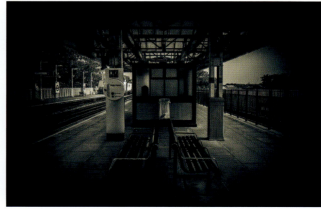

Putney Bridge

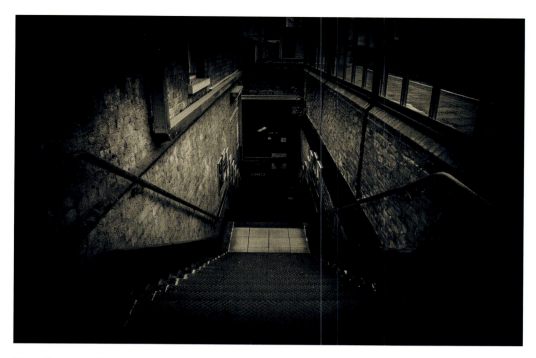

East Putney: There were many options to photograph here, but the bricks caught my attention as they contrasted with the stairs.

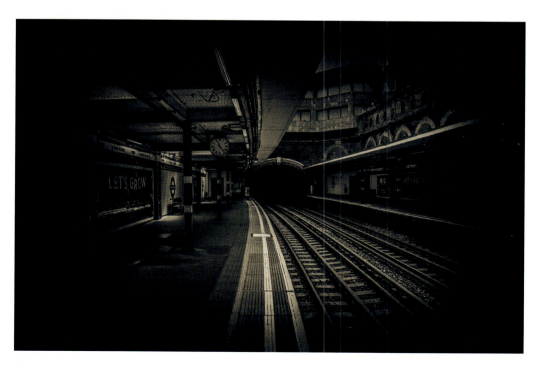

Sloane Square

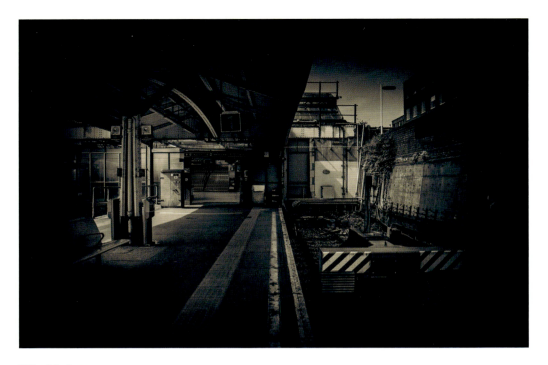

Wimbledon

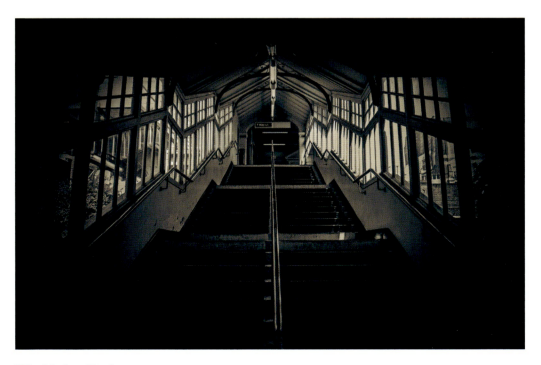

Wimbledon Park

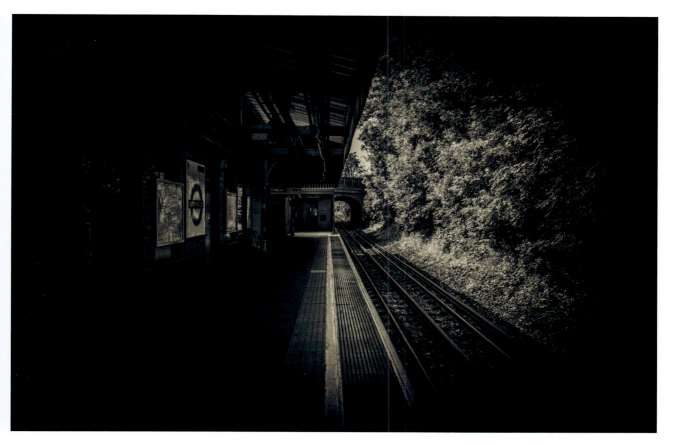

Southfields: The trees almost look like they have been painted in.

Saturday 9 June 2018

This morning was another impromptu trip – I was going to be in London for another reason anyway. It was such a lovely morning, a little overcast but warm. I visited some of the Jubilee line stations on the northern end of the line, including Stanmore. Capturing these end-of-the-line stations is always tricky as they are usually busy, but my patience paid off. I am happy with the shot. I also love the shot of the interior of the Jubilee line carriage.

Today was a good day.

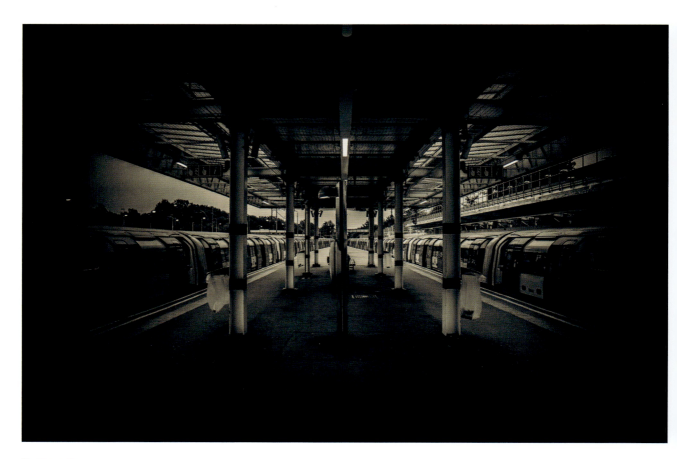

Stanmore

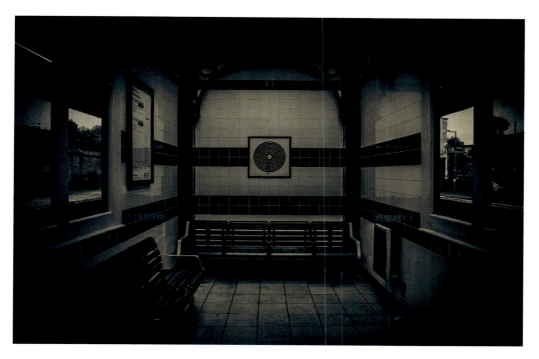

Willesden Green: Take a seat and enjoy the view.

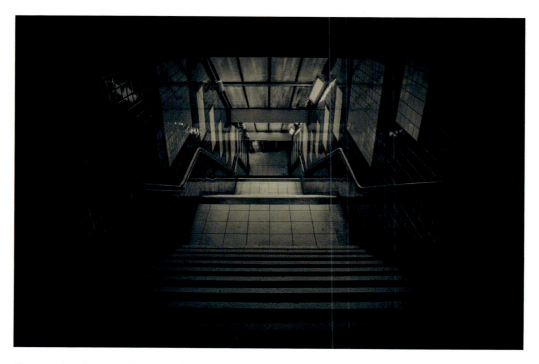

Canons Park: It is photographs such as this one that make me fall in love with this project over and over, despite the many highs and lows.

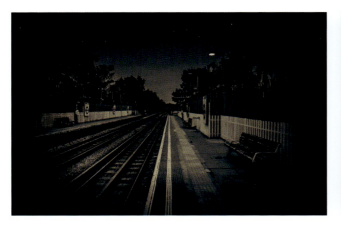

Queensbury

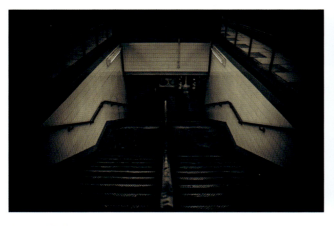

Neasden

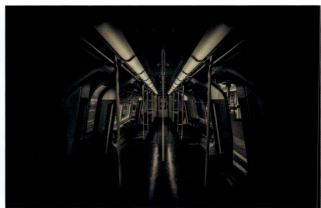

Dollis Hill

Jubilee line carriage

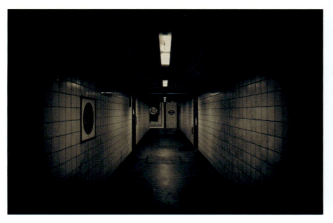

St John's Wood

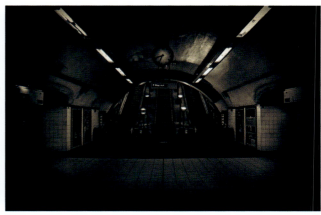

Swiss Cottage

Saturday 4 August 2018

Attempting some of the Metropolitan line this morning and I am really looking forward to travelling to the end of the line to Amersham and Chesham. I know it is going to take a while to get there but pretty sure it will be worth it, the Metropolitan line is the oldest part of the underground network. It feels good to be passionate about this project again and to actually want to visit London. It has taken me a while to get back to having a little more confidence.

———•———

Really pleased with this morning. Chesham was such a beautiful station. It was an odd feeling knowing it is probably the one and only time I will visit. But I guess this is going to be the case for the majority of stations on the network – if I ever complete this project.

I also managed to tag on photographing Finsbury Park – this station had been bugging me for a long time, as it was always too busy. Chuffed that I captured it at last.

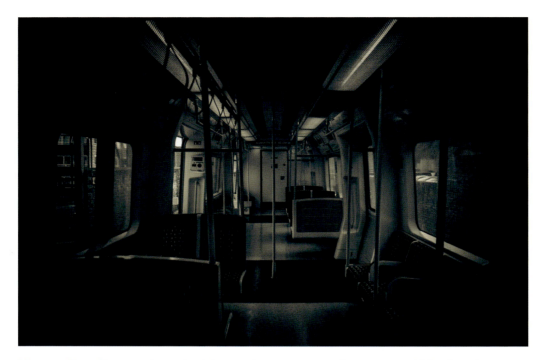

Metropolitan line carriage: A tricky one for me as it wasn't symmetrical like the other carriages. Maybe that's its charm.

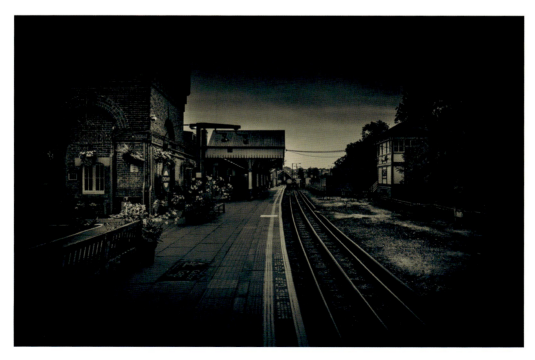

Chesham: The end of line and as far from central London as you can get on the tube.

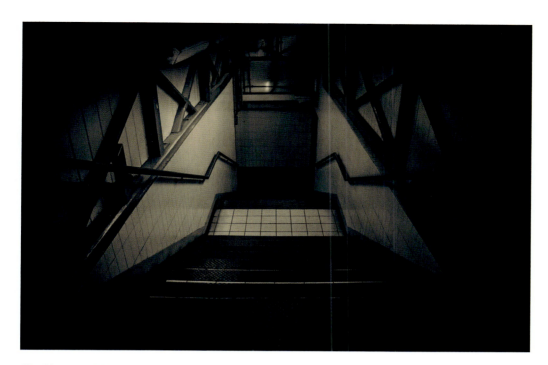

Chalfont and Latimer

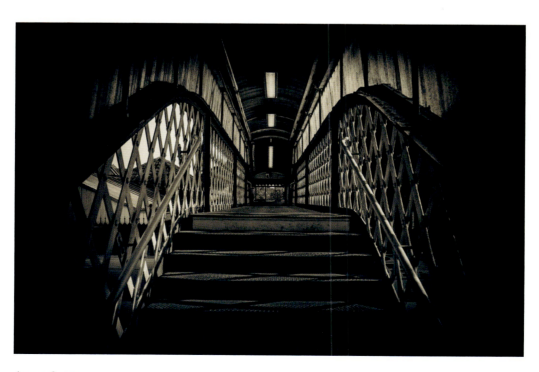

Amersham

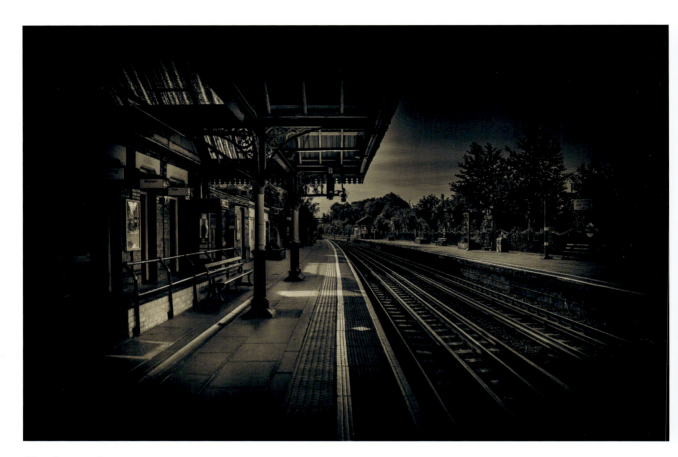

Chorleywood

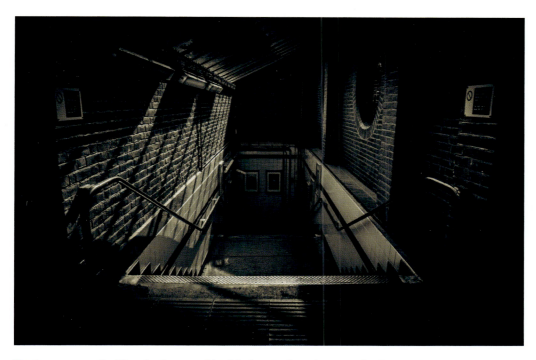

Rickmansworth: The shadows and highlights in this photograph align perfectly.

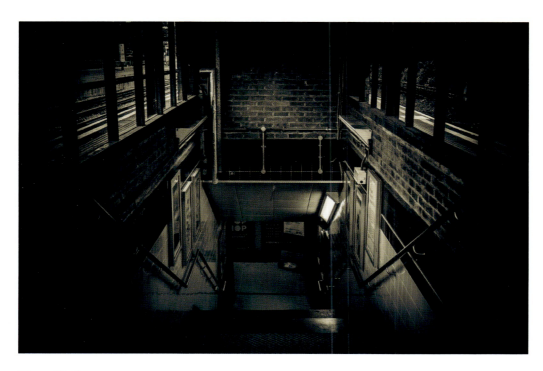

Moor Park

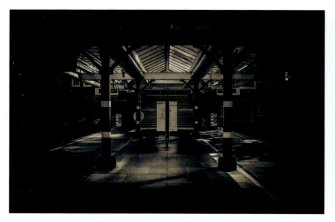

Watford

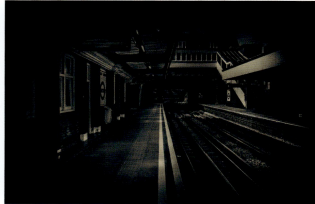

Croxley

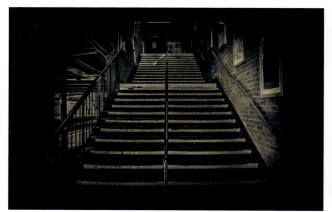

Northwood

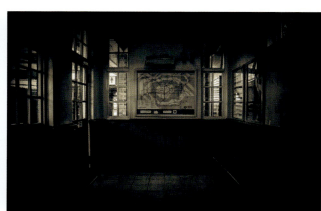

Northwood Hills

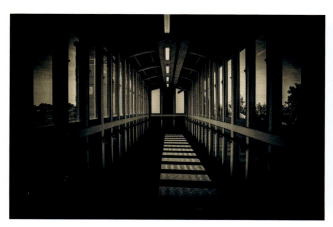

Pinner

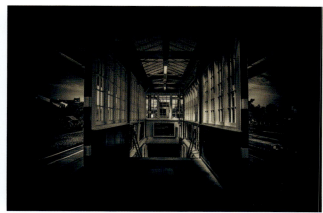

Northwick Park

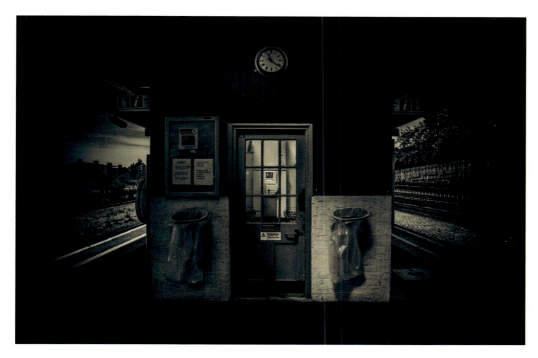

Preston Road: It was getting late in the morning by the time I reached this station, so capturing an empty platform was becoming more difficult and I was feeling more uncomfortable.

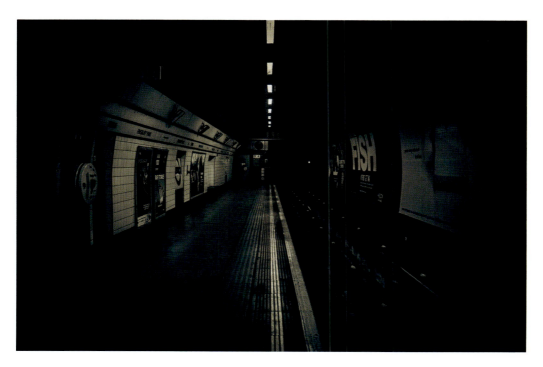

Finsbury Park

Sunday 12 August 2018

This morning I am visiting more of the Central line and planning to travel all the way to Epping. Being a Sunday, it should be pretty quiet. The trouble is that Sunday timetables are going to make it a lengthy trip. One of the first stations on my trip is Ealing Broadway – after what seems like an eternity I *still* haven't captured this station. I would also like to get Shepherd's Bush.

— · —

This was a productive day though it was long, cold and tiring. I'm looking forward to getting home and having a nice, hot bath. The stations on my list were mostly quiet. There were only a few that were too busy to photograph, so they are on the list for next time.

This morning was tough because I had to wait so long for the next train, even after I had got the shot I wanted. And when I have to wait, my mind goes into overdrive and the unsettling feelings creep in. Today, I just couldn't keep them at bay. But I am positive the photos will look great when they've been edited.

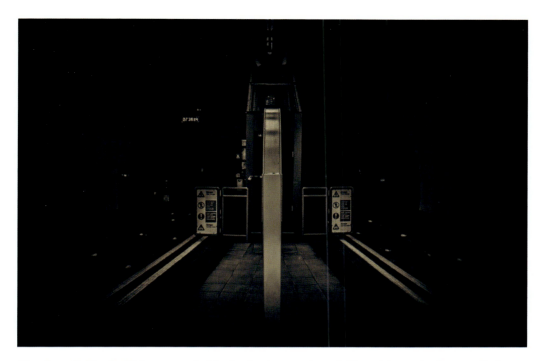

Shepherd's Bush: This was probably the busiest station of all on this particular trip. I chose to photograph away from the platform and I'm pleased with the shot.

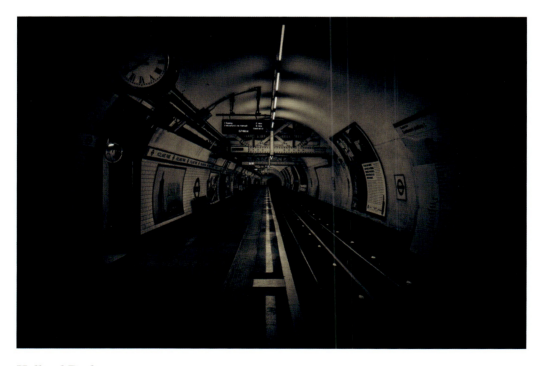

Holland Park

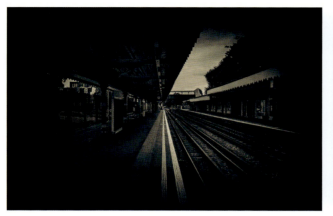

Snaresbrook

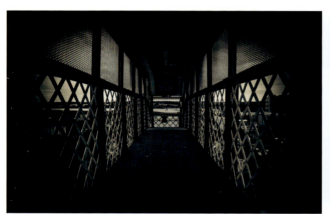

Buckhurst Hill

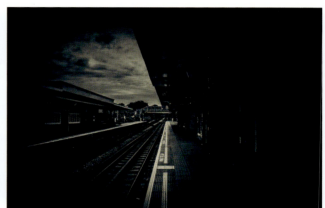

Debden

Theydon Bois

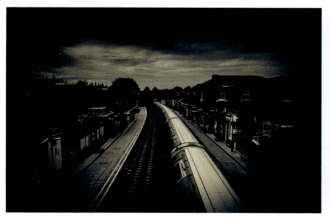

Epping

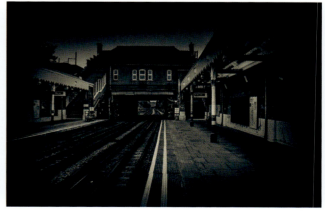

Chigwell

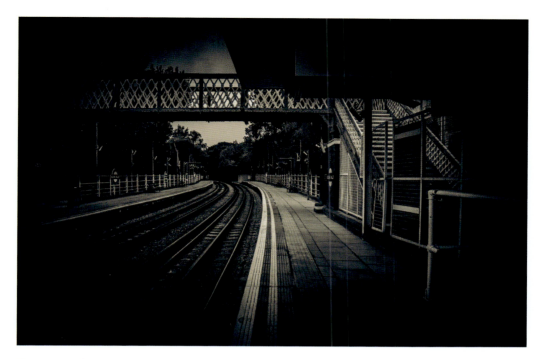

Roding Valley

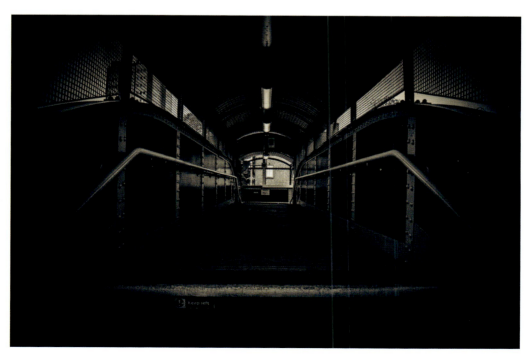

Woodford: Keep Left!

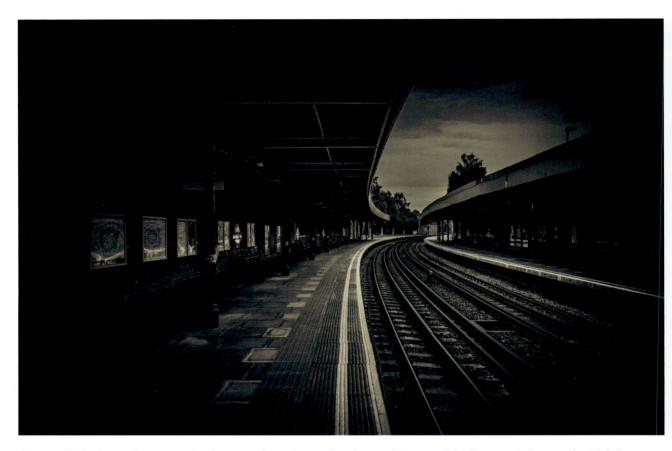

Grange Hill: It wasn't easy getting here, as the trains on Sunday on this part of the line run infrequently. I felt I was stuck in the middle of nowhere.

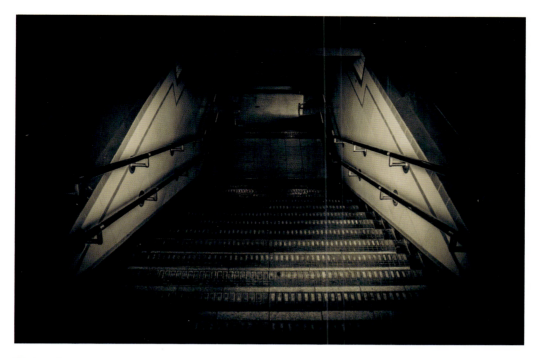

Hainault

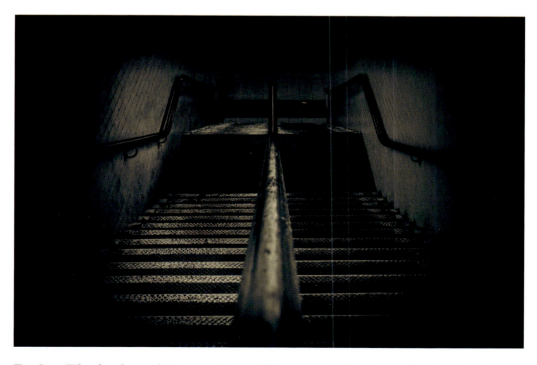

Fairlop: What lies beneath? I can understand how some of the photographs in this project look creepy and eerie.

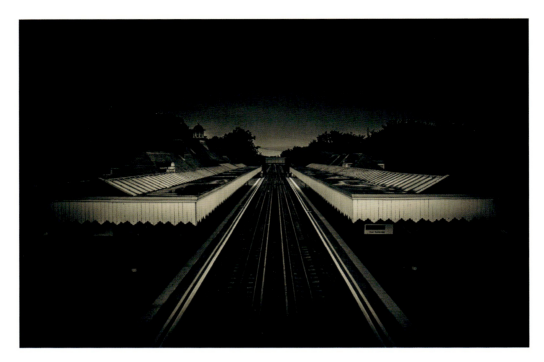

Barkingside

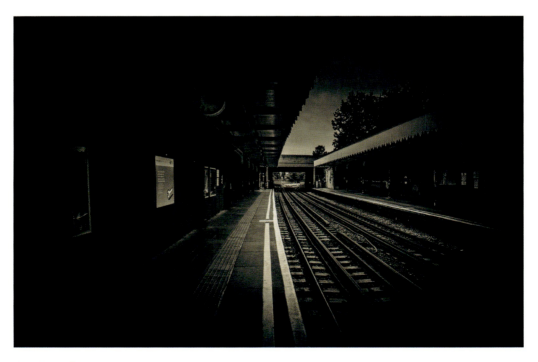

Newbury Park

Thursday 6 September 2018

Today is a complete mix of emotions. I am meeting my editor and this project is actually going to be published. It is a dream come true, while also terrifying at the same time.

This is the first time I have been out since I had what is called a cardiac episode in August. I have not been so scared in a very long time. Being told there is something wrong with your heart really turns everything upside down and I questioned everything. Thank goodness for amazing parents, friends and family. This year has certainly thrown me some curveballs and I honestly didn't think I would make it through.

On my way into central London, I decide to stop off a few stations on the way and take some photographs. I was lucky that they were quiet. The Heathrow stations are beautiful, and I am pretty chuffed that I have completed this part of the Piccadilly line.

Amy should be here soon and it will be super exciting to discuss the book. After a hard year, it is a dream come true at last.

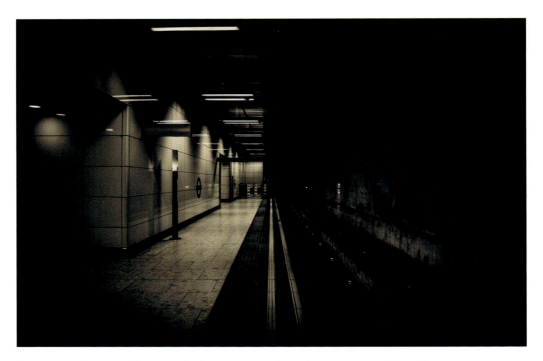

Heathrow Terminal 5: Considering this is a relatively new station, I found it stunning to photograph.

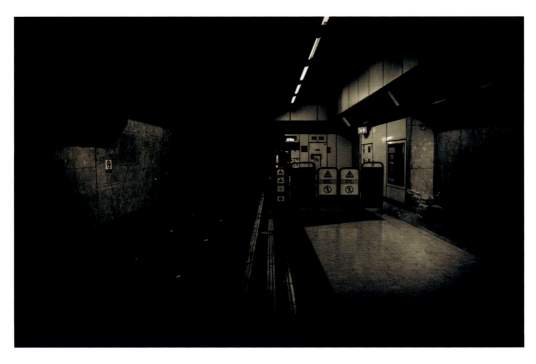

Heathrow Terminal 4: This was a strange little station with only one platform, but surprisingly it took a long time to capture the shot.

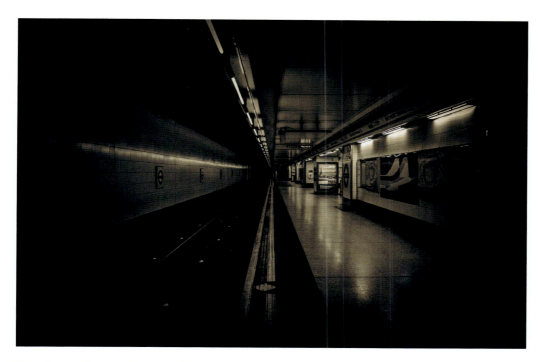

Heathrow Terminals 1, 2 and 3

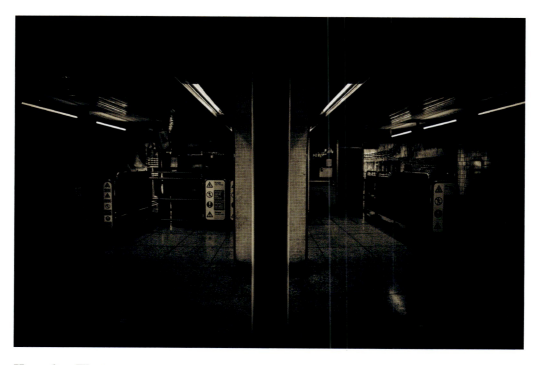

Hounslow West

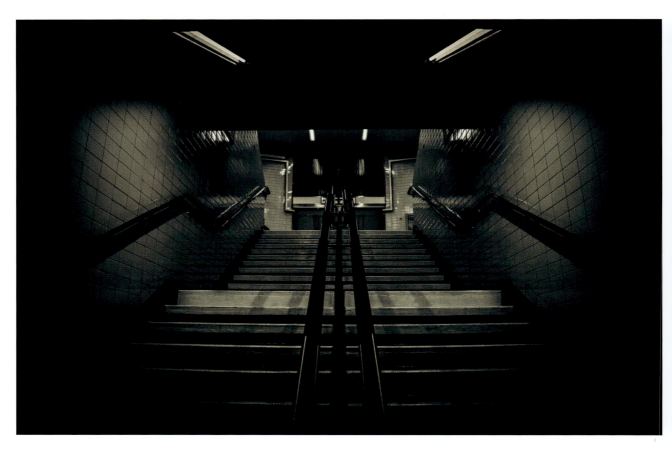

Hatton Cross

Saturday 8 September 2018

It is a big morning for me today. After a successful visit to London on Thursday, I wanted to come in today and continue finishing-up the project. Notting Hill Gate is next on the list and I want to get there early enough that it is still dark and empty – it has been a particularly tricky station to photograph. The plan for the rest of the morning is to capture as much of the District line as possible. The 3.30 a.m. start is going to be really tough, and I know it is going to be exhausting, but I have a goal to finish now. All the hard work and the ups and downs have paid off – I can do it.

Notting Hill Gate was stunning in the dark and completely empty. I absolutely love this photograph. I could have sat on that platform for hours and just enjoyed the stillness, I didn't want to leave. And writing this, I never thought I would feel that way about being at a Tube station. Of course, the feeling disappeared as soon as someone else stepped foot on the platform. But for a few minutes it was all mine and in that photograph it will stay mine forever. I feel proud. The other stations were quiet and I got some great shots – but they weren't Notting Hill Gate.

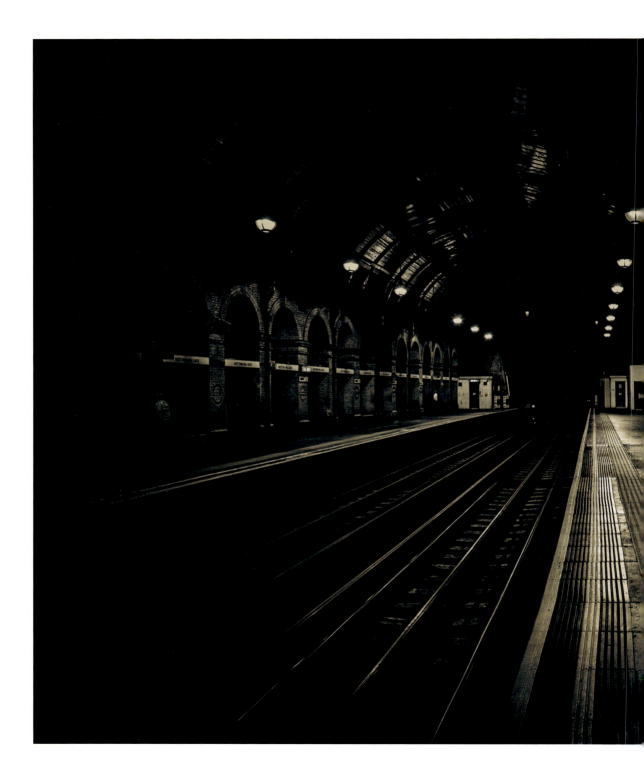

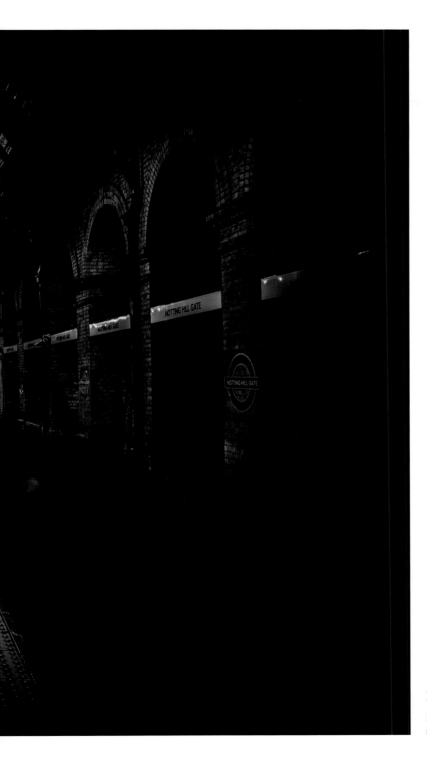

Notting Hill Gate: An incredibly proud moment capturing this station empty.

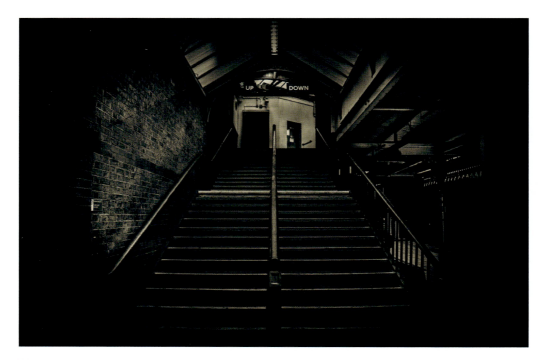

Plaistow

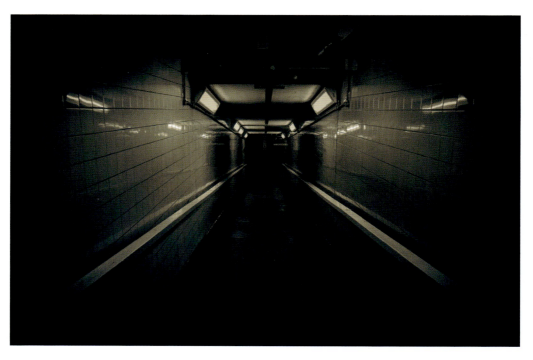

Barking: I didn't expect to find this tunnel here, and I was so glad I did. I love it!

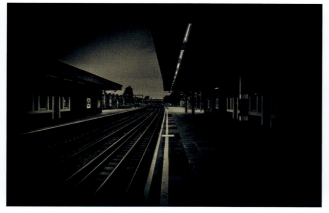

Becontree

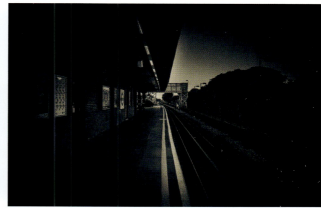

Elm Park

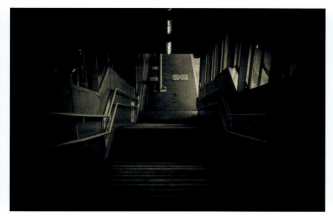

Upminster

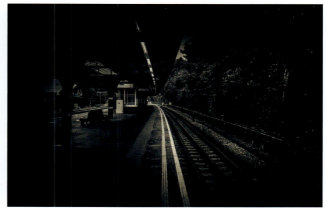

Upminster Bridge

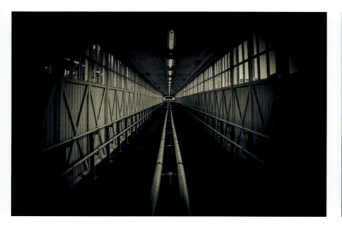

Dagenham Heathway

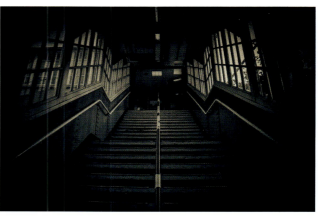

Dagenham East

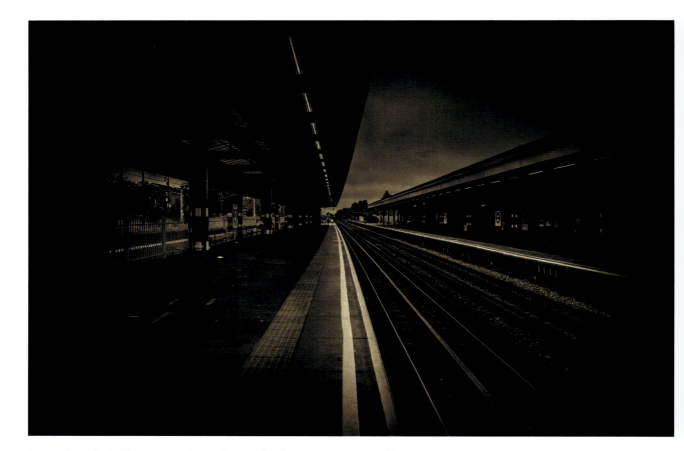

Hornchurch: This was one of two shots only. A rare moment of stillness and symmetry.

Sunday 23 September 2018

I am visiting the top of both branches of the Northern line this morning. The weather forecast shows heavy rain for the morning, this could be good for me because it will add interest to the value of the image. Rain can make the ordinary look extraordinary. If I photograph all of the stations on the list, it means that the Northern line is complete! That will be a monumental achievement.

I am starting to feel the pressure, which is probably a good thing. But it is all consuming and lets the unsettling feelings creep back in. It is a constant battle to try to keep them at bay. I will be so pleased when this project is finished because it means I will have achieved something I never thought I could – visiting all 270 Tube stations. It also means I don't have to keep fighting the negativity and anxiety, I can visit London only when I feel comfortable enough.

———◆———

Well, it was a very wet and cold morning and I am feeling the effects as I write this while sat in a coffee shop trying to warm up. My frozen fingers still don't want to work. I photographed a lot of stations this morning, and once I get home to edit them, I think I might have finished the Northern line. One station offered up an amazing opportunity and I was so excited – Archway and the boot! As I got off the train here, it was just there waiting for its owner to return. Maybe they had such a great night they didn't realise they had left it behind. Anyway, it was photographical gold for me!

There were a couple of times when I felt uncomfortable but I talked myself through those feelings. As much as the rain will make some of the photographs look amazing, it was horrible weather to be out and about in. It did mean that most of the stations were quiet and so meant that I could be far more productive. The finishing line is getting closer now and it is an exciting feeling. For now, time to head home for a hot bath.

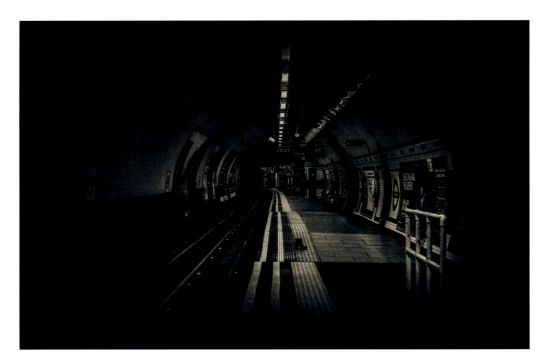

Archway: The lone boot.

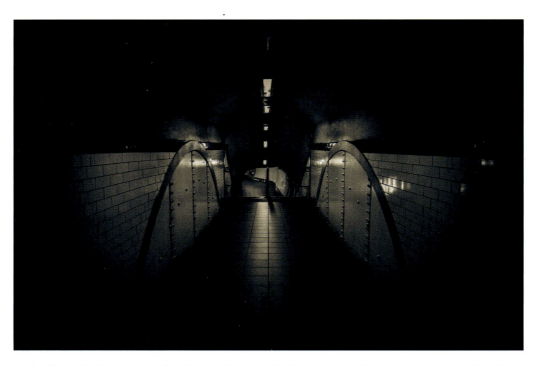

Tufnell Park: Very pleased with this photograph. It is a beautiful station with a wonderful atmosphere.

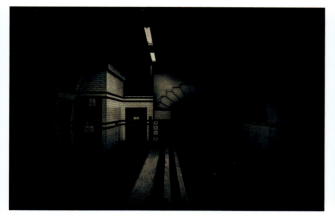

Kentish Town

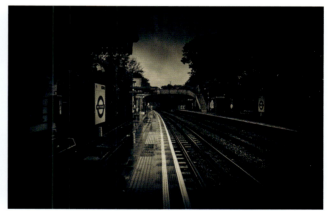

East Finchley

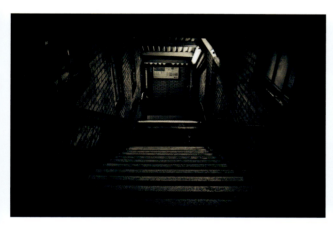

Mill Hill East

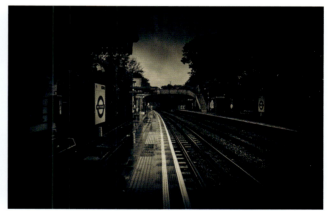

West Finchley

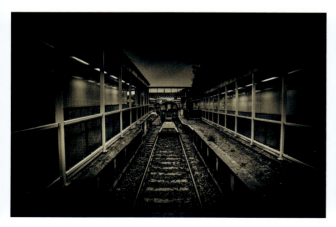

High Barnet: The end of the line.

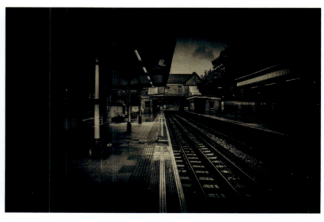

Totteridge and Whetstone

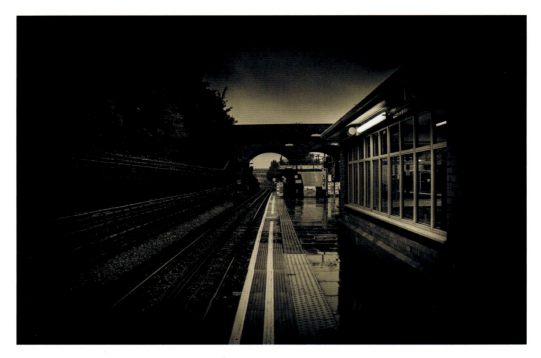

Finchley Central: I felt like a drowned rat waiting to get this photograph.

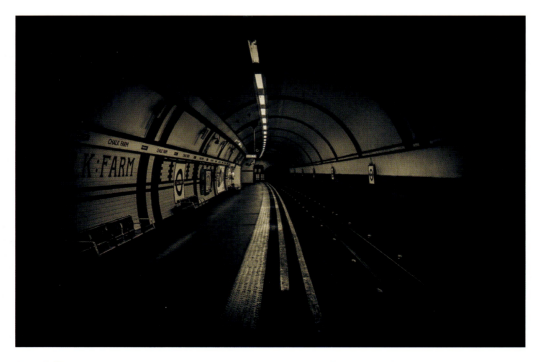

Chalk Farm: After being outside most of the morning in the cold and the wet, it was a welcome relief to sit for a while in the warm and take a breather.

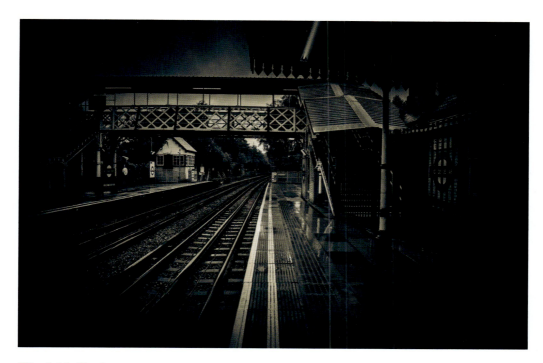

Woodside Park

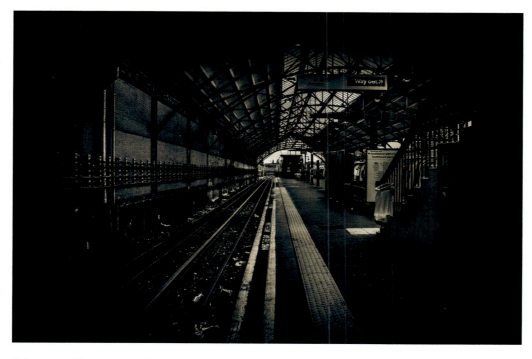

Edgware: This wasn't what I was expecting when I reached this station. It felt very messy.

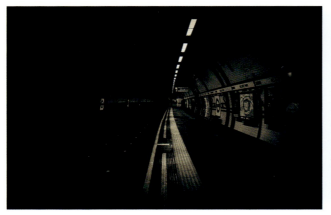

Belsize Park

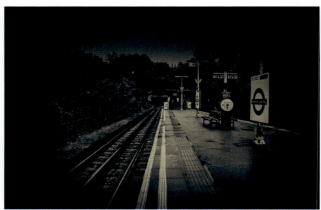

Golders Green

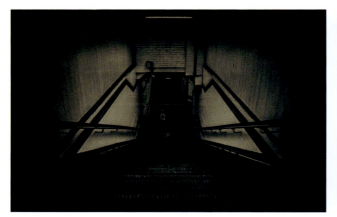

Brent Cross

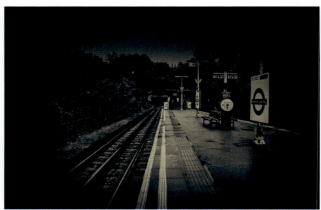

Hendon Central

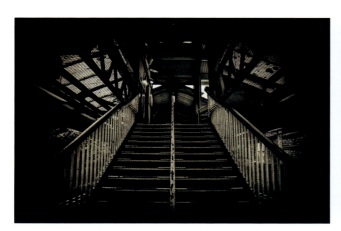

Burnt Oak

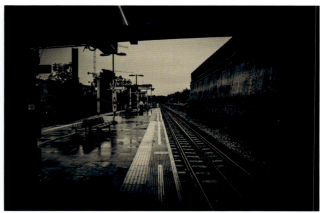

Colindale

Saturday 29 September 2018

Ealing Broadway is on the list for this morning. This is a shot I have been waiting to get for what seems like an eternity. I am hoping to get there around 5 a.m. and will wait for as long as it takes. This is one of my favourite stations as I used it a lot when I was at university. I want to do it justice so to speak.

Other stations on the agenda for today are random ones really. As the project is nearing completion, there are stations all over the network that still need to be visited or revisited. This is going to be a very tiring day. I have an audiobook downloaded for the trip; I hope that this will help keep any unsettling thoughts away.

It was freezing at 5 a.m. I was exhausted and Ealing Broadway was busy – really busy. I was honestly gutted. There were a few stations on the Central line that I needed to visit, so I went back to Ealing Broadway before hopping onto the District line towards Chiswick Park and Aldgate East. When I went back, I hit the jackpot. While I was waiting for the District line it was quiet for about five minutes and I love the photograph I was able to capture, I'm looking forward to editing it.

The other shot I am proud of this morning is the one taken at Aldgate East. I think I have lost count of the number of times I have visited this station and waited for a brief moment of peace and quiet, but it has always been busy. I was feeling overwhelmed and decided to go outside for some fresh air and there it was. The shot I wanted was right in front of me. That was a *good* feeling. Pretty chuffed with all of the other station photographs I collected today.

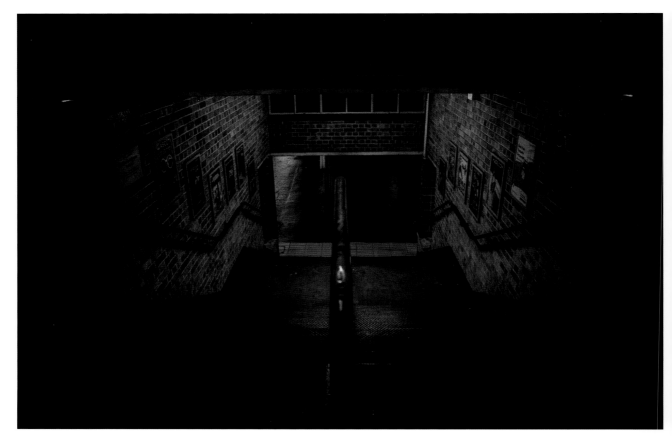

White City: I thought this was going to be a station that would be difficult to capture a decent perspective. Happy to say I was proven wrong.

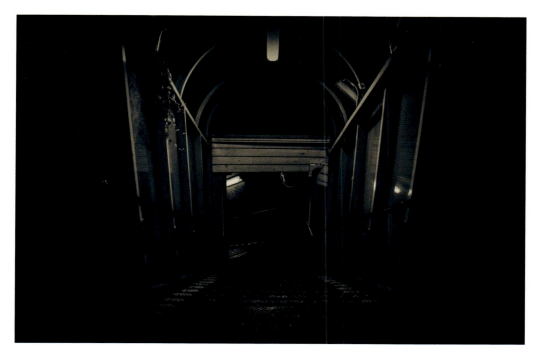

East Acton

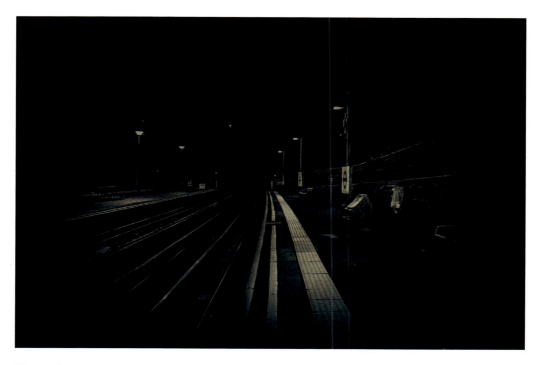

North Acton

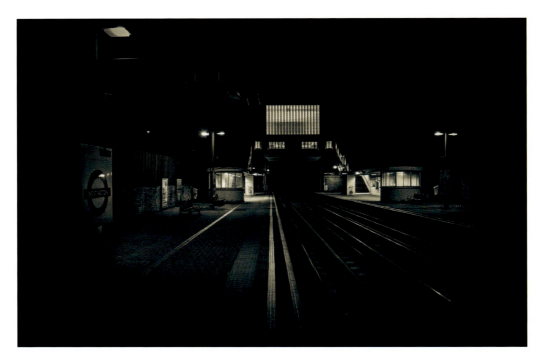

West Acton

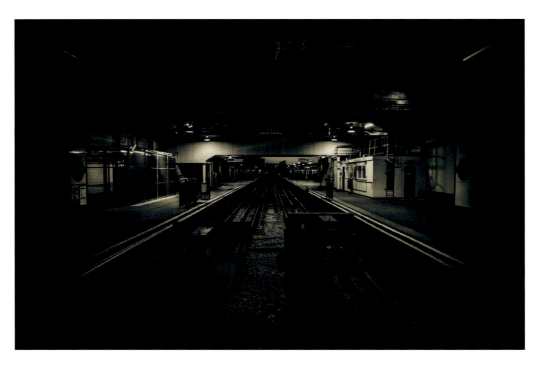

Ealing Broadway: Another photograph that was worth the wait to capture.

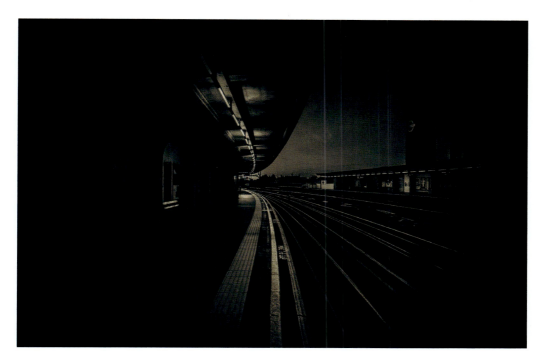

Chiswick Park

Aldgate East: Still pretty pleased with this one. The tricky ones are always worth the time and patience.

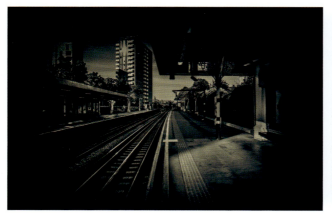

Bromley-by-Bow

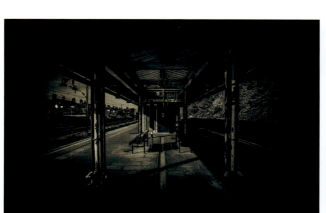

Upton Park

Upney

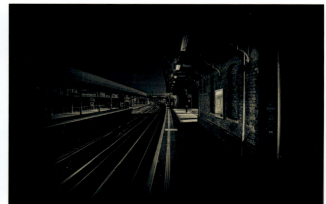

East Ham

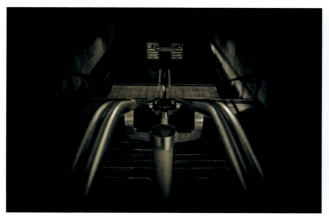

Canning Town

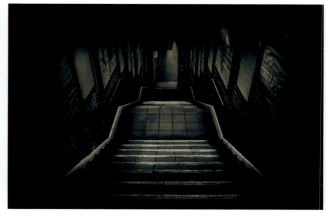

Kingsbury

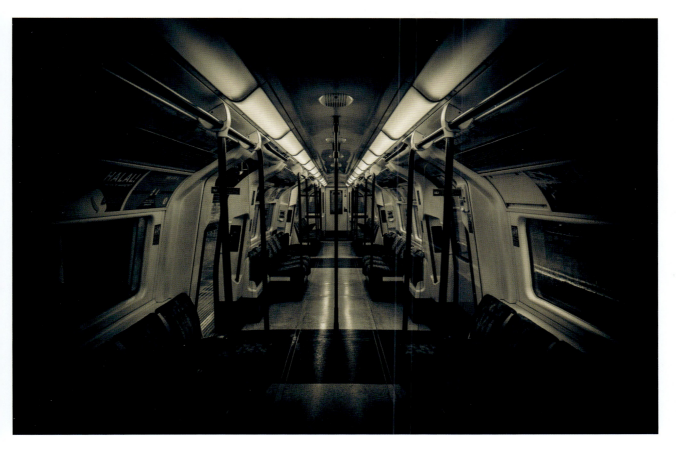

Northern line carriage

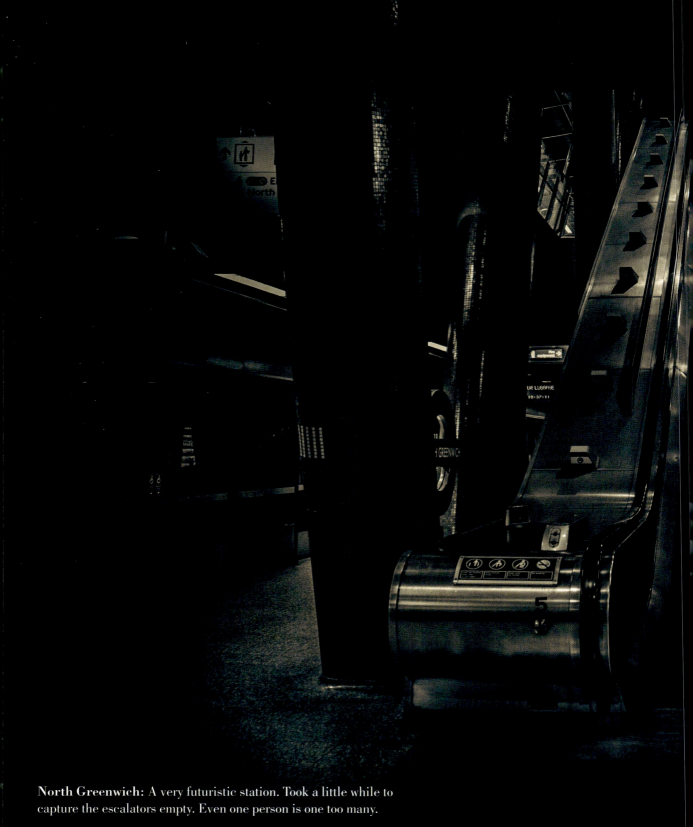

North Greenwich: A very futuristic station. Took a little while to capture the escalators empty. Even one person is one too many.

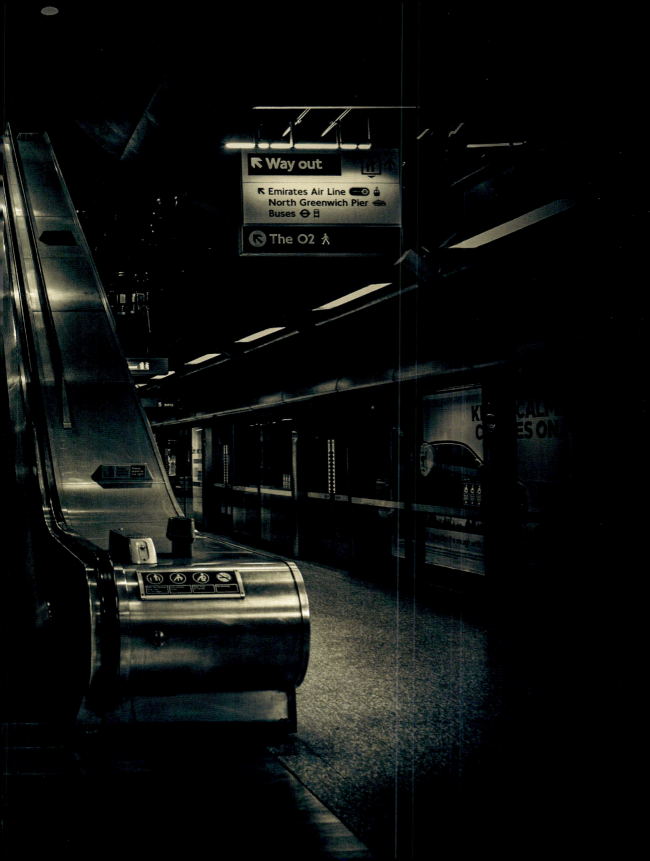

Sunday 7 October 2018

I did sit down to write in my diary last night before this trip, but I really felt that I didn't want to go, so anything I wrote would have been very negative and wouldn't have helped me this morning. I went into London from Hatton Cross this morning, something I have not done before. I parked up at the station just before 5 a.m. and waited for the next train into London. I didn't feel great. The idea of departing from somewhere different set off my anxiety and I barely slept. My confidence was at an all time low and I wanted to turn around and go home. But being so close to completing this journey kept me from giving in that easily.

I struggled for the whole trip. I felt vulnerable, self-conscious and didn't have any confidence to stand up with my camera and take a photo. It can be a very dark place when you are thinking like that, and as I sit and write this now I want to cry. Why do I put myself through this? But I guess if something is worth doing, it's not going to be easy.

Photography-wise, I stood up and got the job done. Today I've photographed more stations in one trip than I think I ever have before! It was exhausting but I love the shot I got at Boston Manor and at Uxbridge. Harrow-on-the-Hill looks pretty creepy – and I love an empty station. And the sky over West Harrow was beautiful. I think I have a really strong collection of photographs from this morning's trip, and I am looking forward to editing them later. Sometimes the bad days turn out OK in the end.

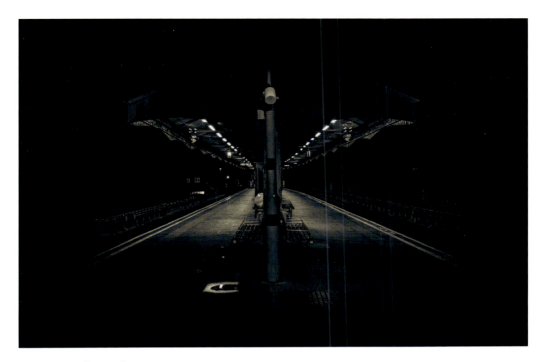

Hounslow Central

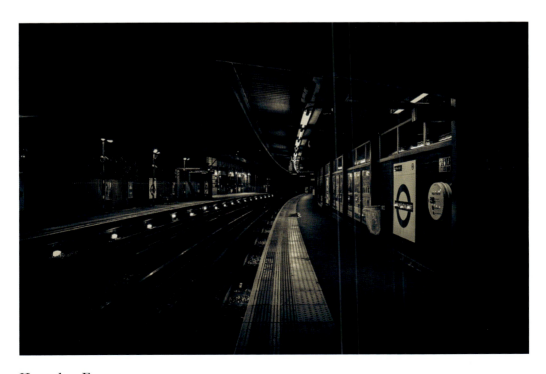

Hounslow East

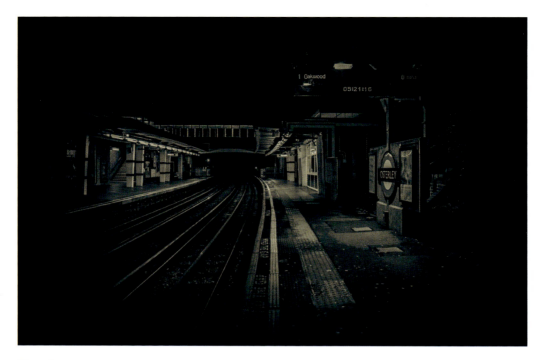

Osterley

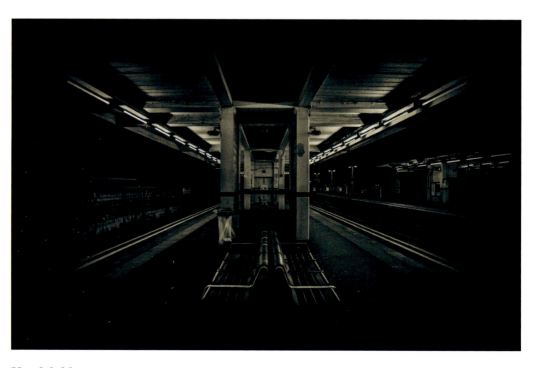

Northfields

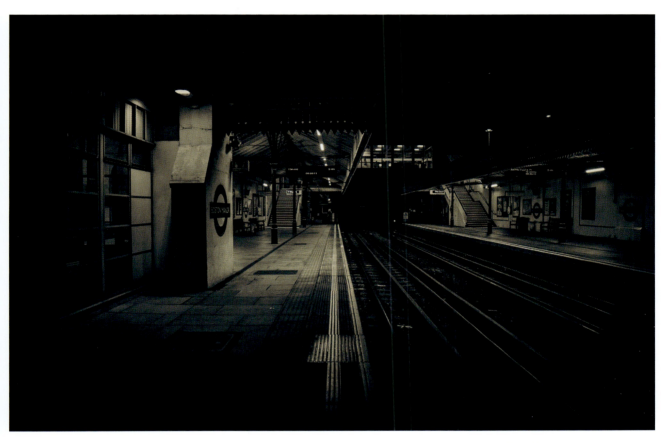

Boston Manor: A cold morning again but worth the early alarm. Not many experience London like this.

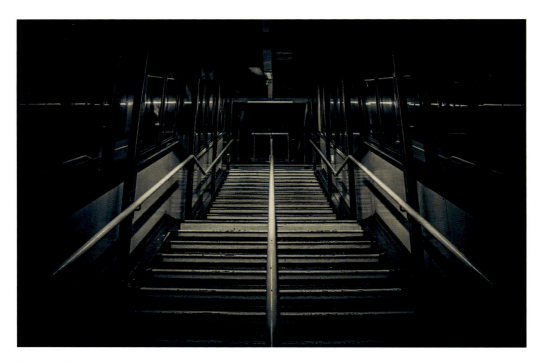

South Ealing

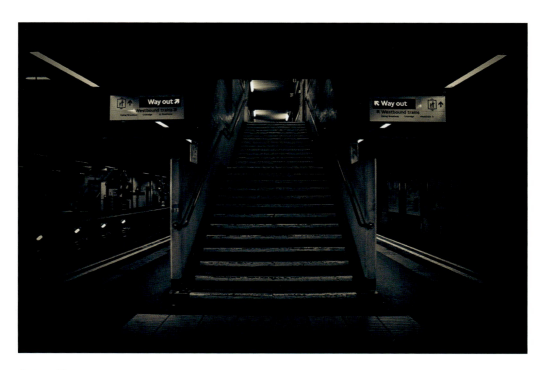

Acton Town

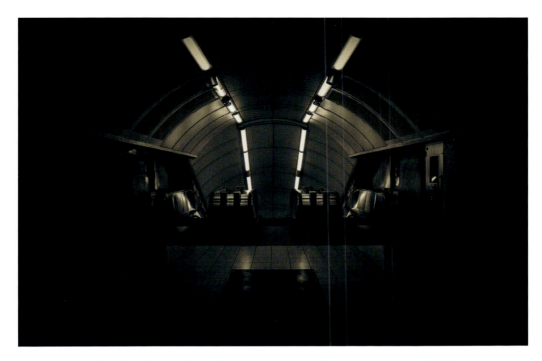

King's Cross: I really thought I would struggle to get a photograph here and I felt very nervous about doing so. It is incredibly hard to carry on when fear takes over.

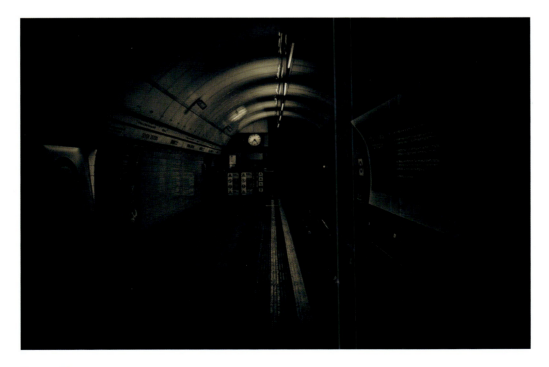

Seven Sisters

Highbury and Islington

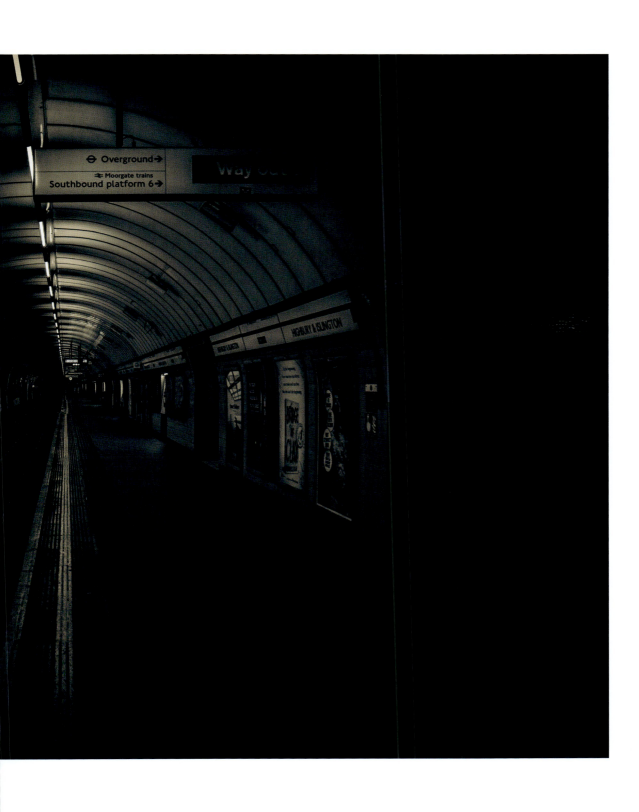

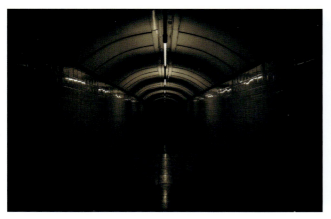

Tottenham Hale

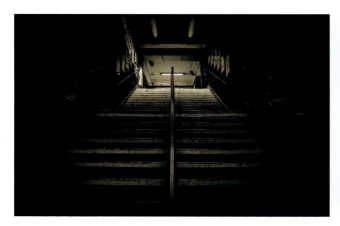

Kilburn

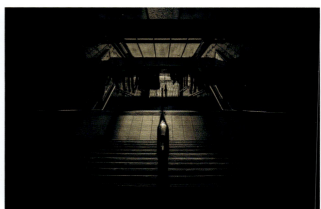

Wembley Park

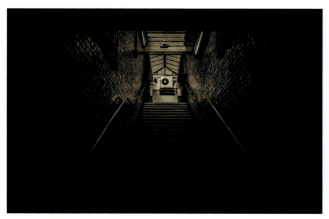

North Harrow

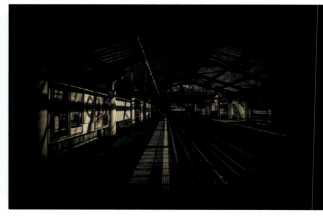

Harrow-on-the-Hill

Hillingdon

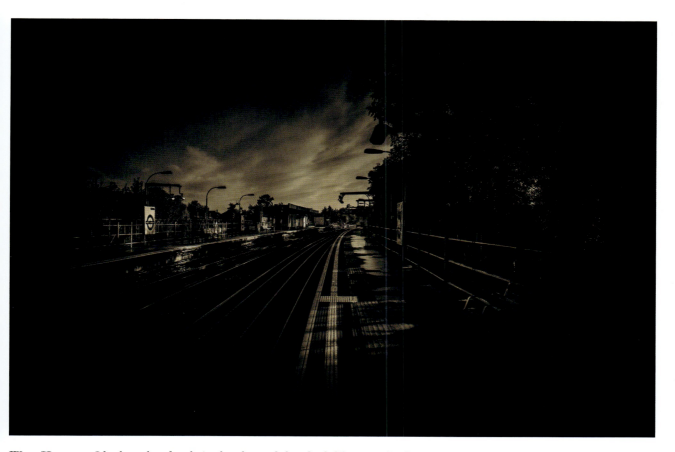

West Harrow: I look at the clouds in the sky and they look like a work of art.

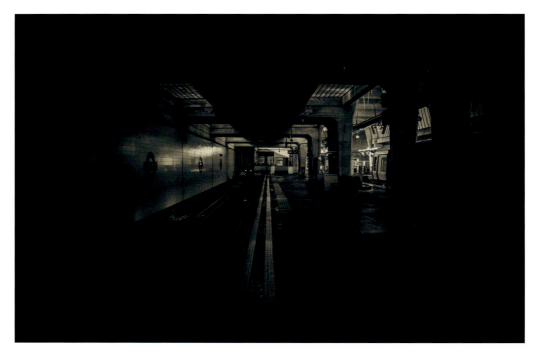

Uxbridge: This shot took some patience to capture. It reminds me a little of Cockfosters station.

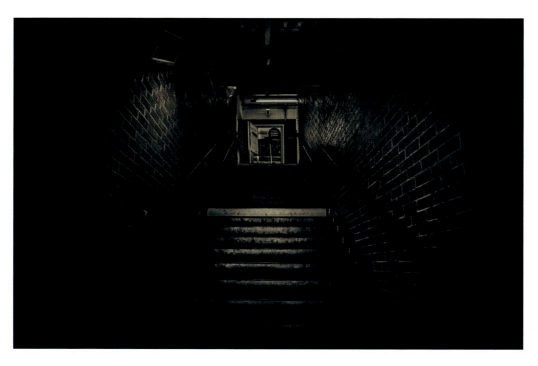

Ickenham

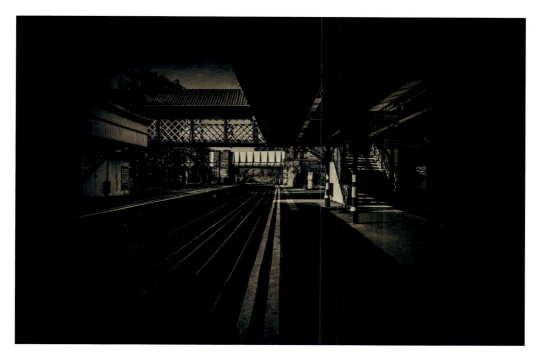

Ruislip

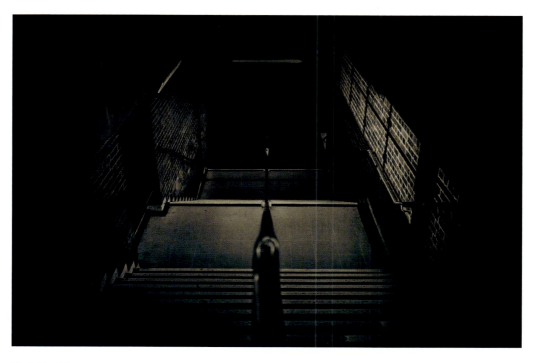

Ruislip Manor

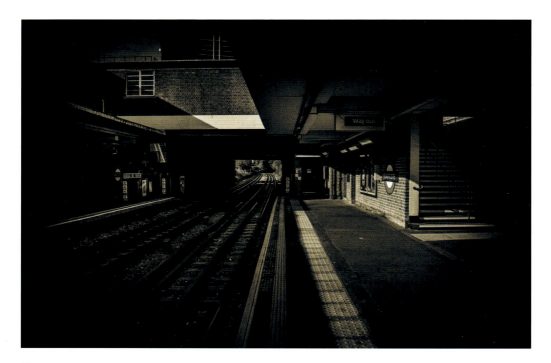

Eastcote

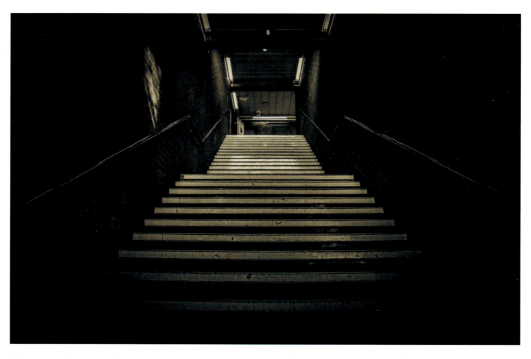

Rayners Lane: It felt like I was waiting forever at this station and it made me feel unsettled.

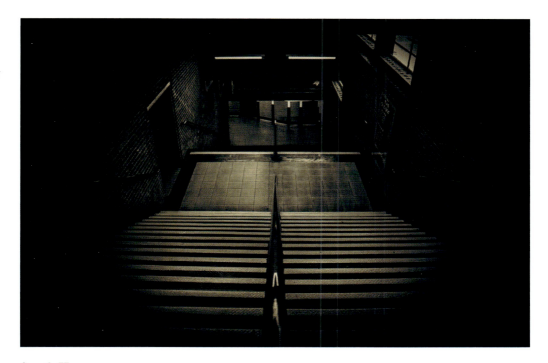

South Harrow

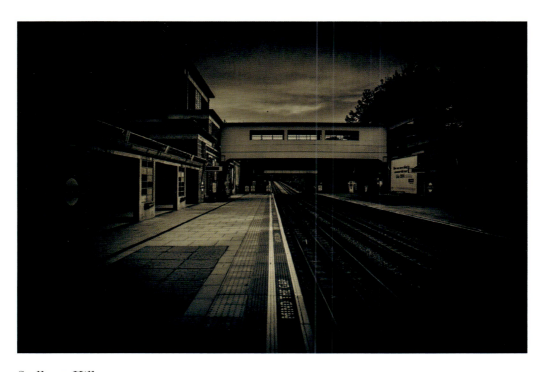

Sudbury Hill

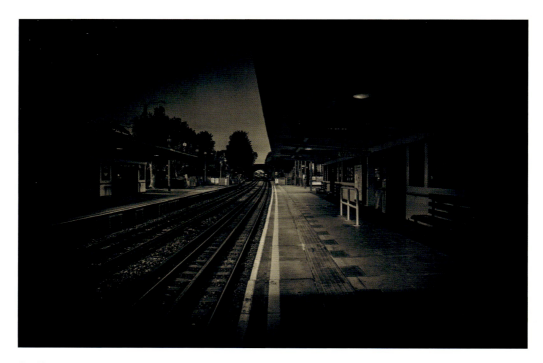

Sudbury Town

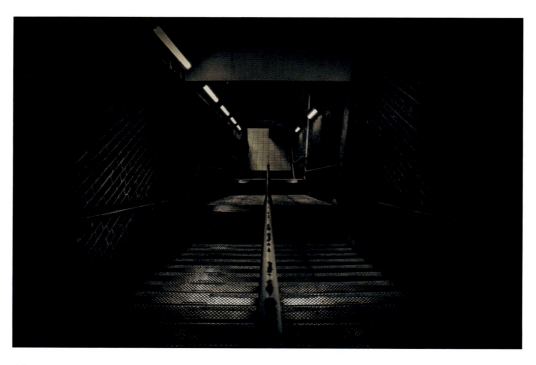

Alperton

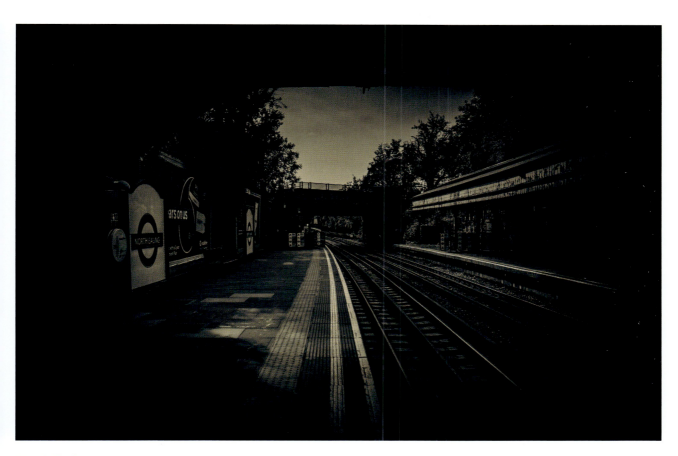

North Ealing

Wednesday 10 October 2018

It seems quite odd to be writing that I am going into London tonight. I have always gone into London early in the morning, and sometimes stayed at the station all day to try to get my photos, but until now I have never gone in for the evening. I hope it will be quiet; I'm not visiting any central London stations. I am going to try to finish the Bakerloo line by going on the northern end of the line and my friend is coming with me. I don't expect to get many shots tonight, but it is worth a try.

———— ·•· ————

Actually it wasn't a bad trip. I photographed seven stations and, considering it was fairly busy, I am happy with that. It was a late one so I am writing this the day after my trip, when I got home last night I just wanted my bed. Having company meant I felt all right and the anxiety stayed away for the most part. Really chuffed to get Wembley Central as that has always seemed to be full of commuters, so did Queen's Park when I think about it. All of the photos are loaded in Lightroom and ready to be edited, picking the best one from each station (I think I always take too many).

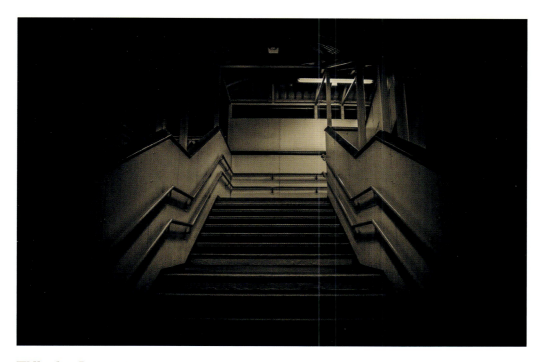

Willesden Junction

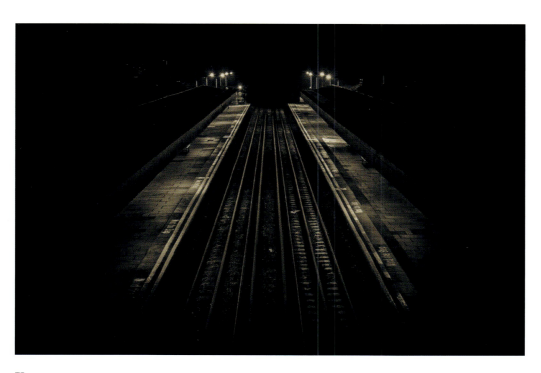

Kenton

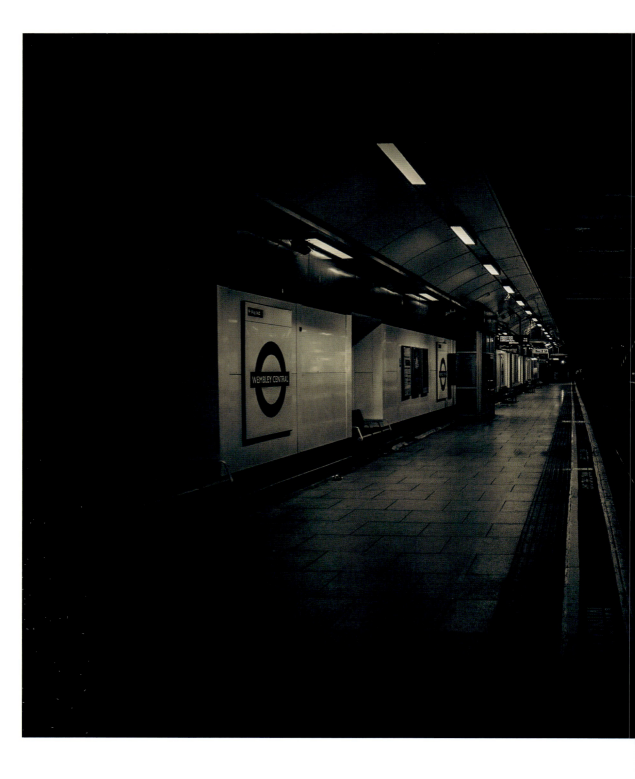

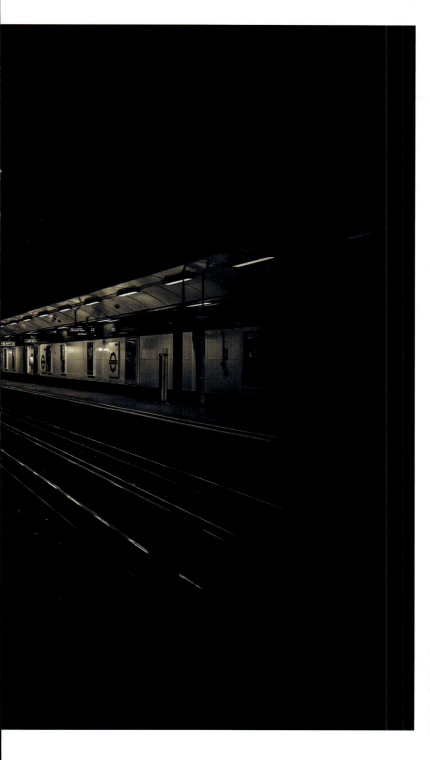

Wembley Central: Extremely happy with this photograph. The few times I've been through here before I thought it would be impossible.

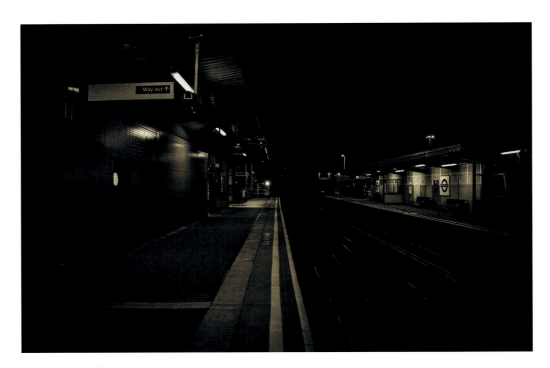

Stonebridge Park

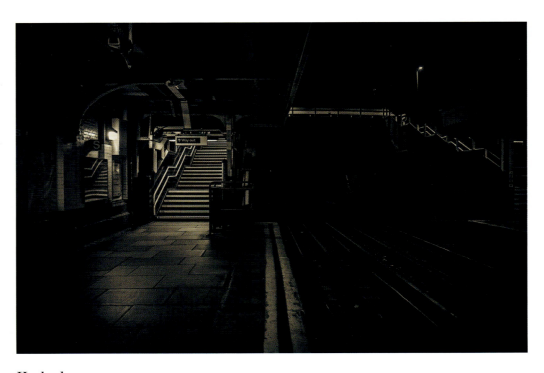

Harlesden

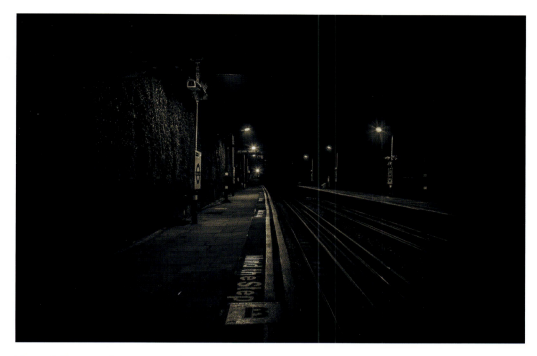

Kensal Green: The peace and tranquillity at this station was wonderful, if only for a second. I love photographing in the dark.

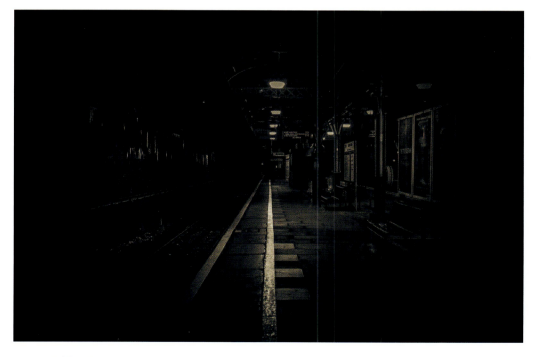

Queen's Park

Saturday 13 October 2018

Cockfosters is my first destination this morning. I am going to park at Hatton Cross and sit on the Piccadilly line until I get there (I think it will take over an hour to get there). Stratford is also on the list and this is a massive station that always busy. The rest of the stations I would like to visit are scattered all across the network. And if I can get all the photographs I want, this will be my last trip. Ever. All 270 stations have been visited and photographed. Scary thought.

———•—————

Before I set out this morning I was nervous. I parked my car at Hatton Cross before heading into London. The anticipation of what was ahead was daunting; I could feel the pressure and the anxiety. But I had a long journey from one side of the network to the other, this was an opportunity to plug in my headphones and zone out.

This continued until I reached central London. And then something happened that has never happened to me before. Two young people came and sat near me at the end of the carriage, and they started talking. They asked me what I was doing. And a conversation started. It was lovely. They were still a bit tipsy which was funny. Talking to them made the world of difference to me and I relaxed. I enjoyed talking about this project and they seemed interested. They stayed on the train until Cockfosters, and even asked me to take a photo of them in the station (I will keep the photo in case they ever read this and get in touch), and whoever you were, thank you!

Cockfosters was beautiful. It is such a stunning station and I love the photo I took here. Oakwood looked great in the dark too. Stratford was as busy as I thought it would be, and the shot from the stairs up to the platform looks like something from a sci-fi film. I worked really hard this morning to visit all of the stations I had left to visit, not forgetting Kensington (Olympia), which I nearly did! The other stations weren't quiet but I had opportunities to photograph them empty thanks to lots of standing around and waiting. All it takes is a few brief seconds and it's done.

As long as all the photographs I have taken this morning look good once edited, then that's it – I am finished. No more early mornings, anxiety or worrying. It is a peculiar feeling. I know I am going to miss it. As I write this now I know in a few months' time I will want to go back despite the anxiousness, unsettled feelings, lack of confidence and vulnerability. This project has kept me going through some rough times, especially this year. It has been a focus, something I cannot quit. And now it is done, it is no more. For now, London, goodbye.

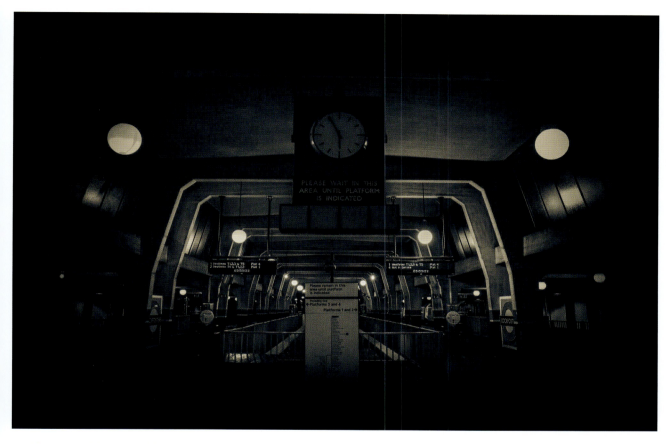

Cockfosters: The story behind this photo still makes me smile. I hope they read this someday.

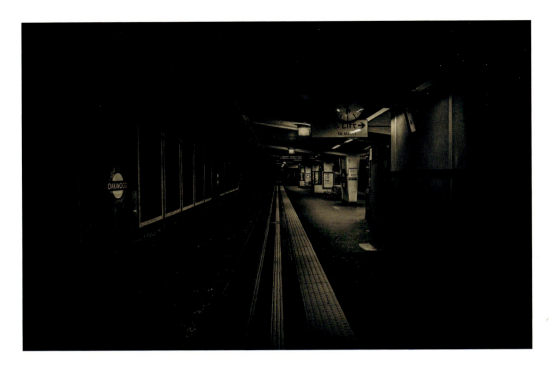

Oakwood

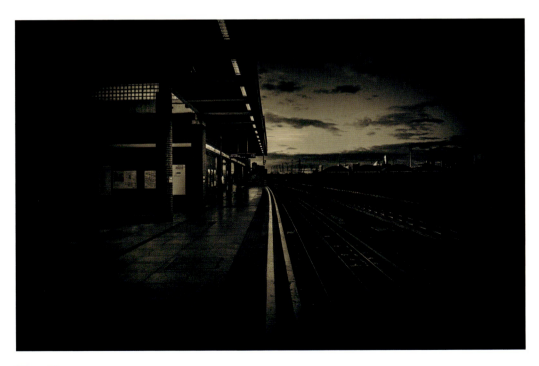

West Ham

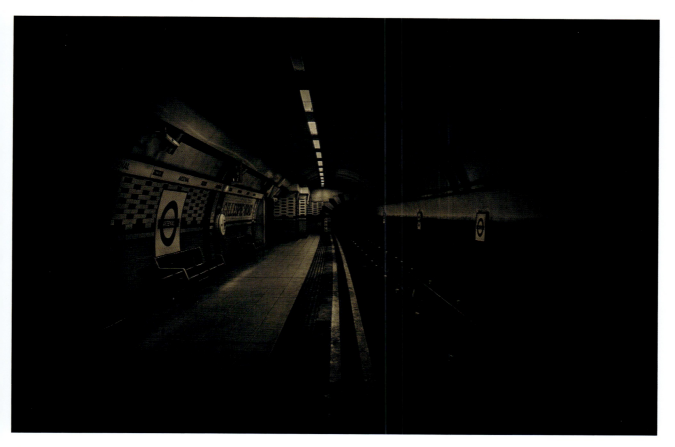

Arsenal

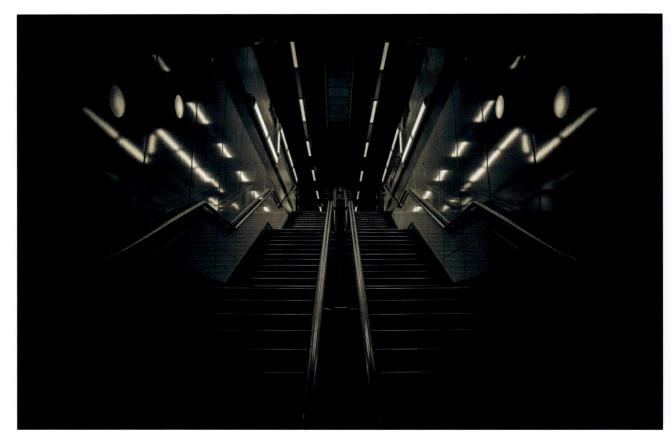

Stratford: This felt like an impossibility to capture but just a few seconds of waiting I grabbed my chance.

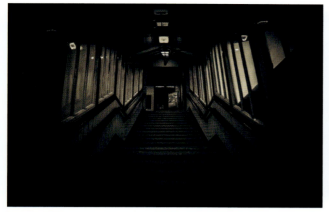

Leyton

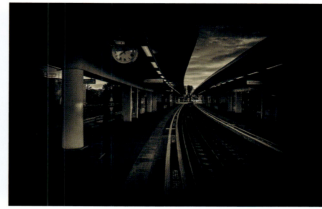

Loughton

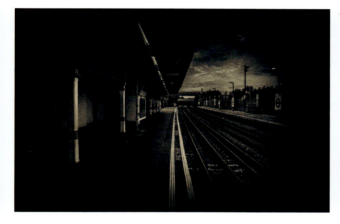

South Woodford

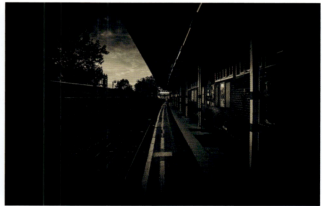

Leytonstone

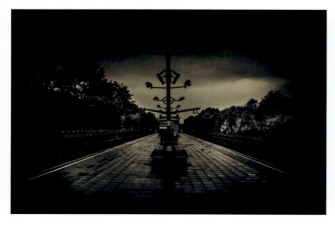

Northolt

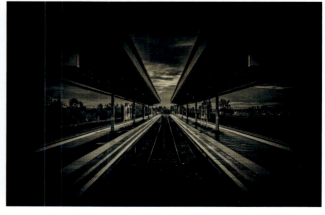

Greenford

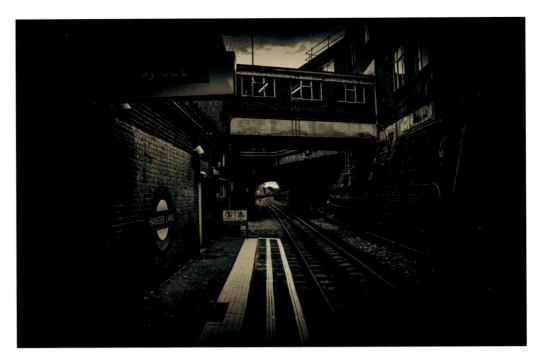

Hangar Lane: My plan here was to photograph the platform in the other direction, but as soon as I saw this I knew I had the shot I was after.

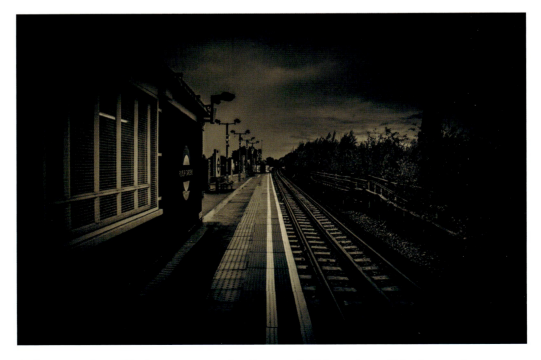

Ruislip Gardens: The heavens opened as I stepped off the train and I had to run for cover. Then in a flash it was all over.

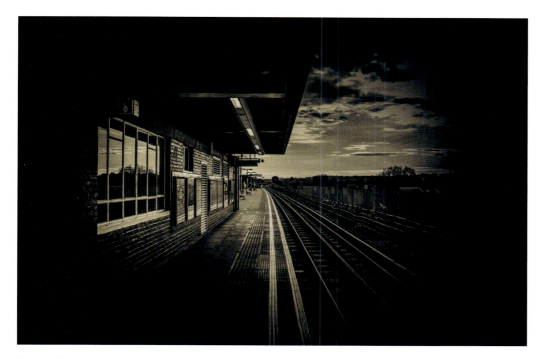

Perivale

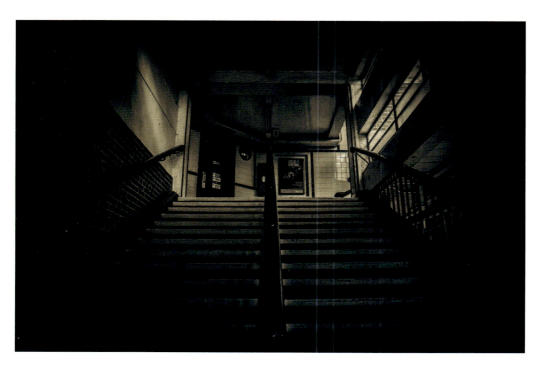

Ealing Common

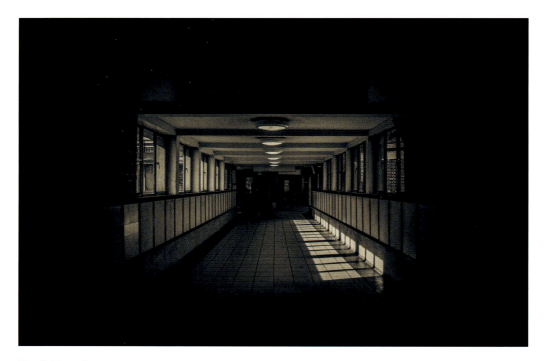

Park Royal

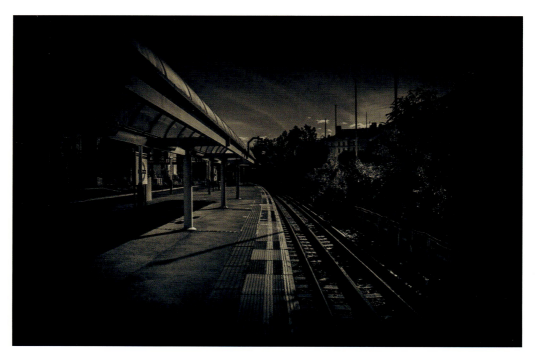

Kensington (Olympia)

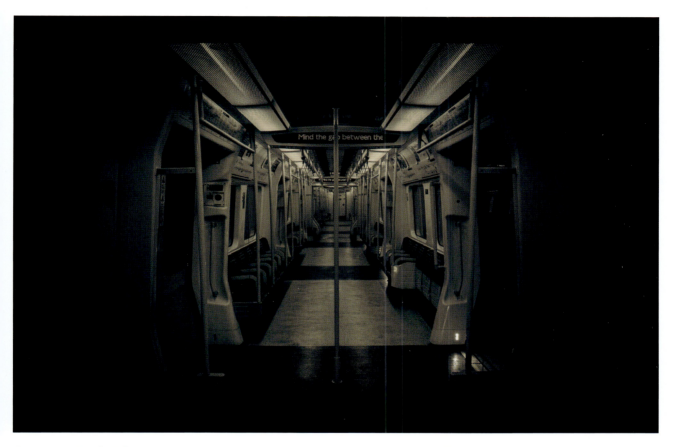

District and Circle line carriage: As always, these empty carriages are beautiful.

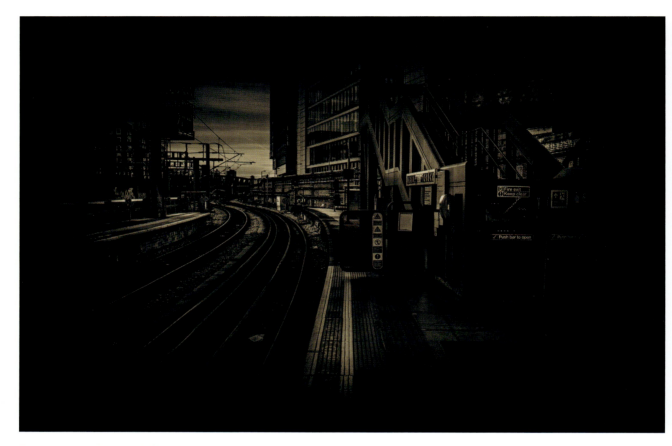

Paddington (Bishop's Road)

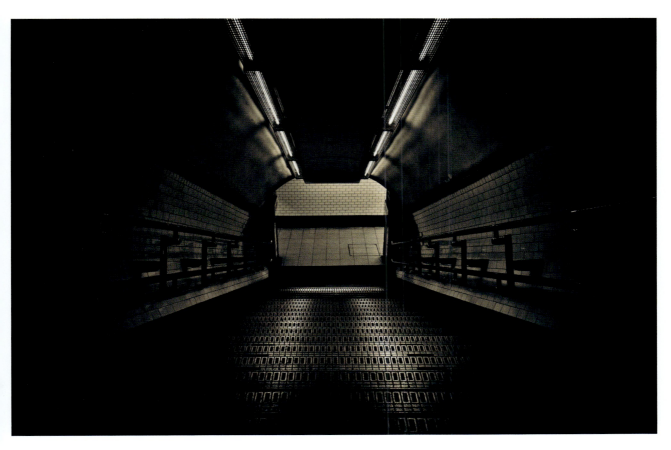

Elephant and Castle

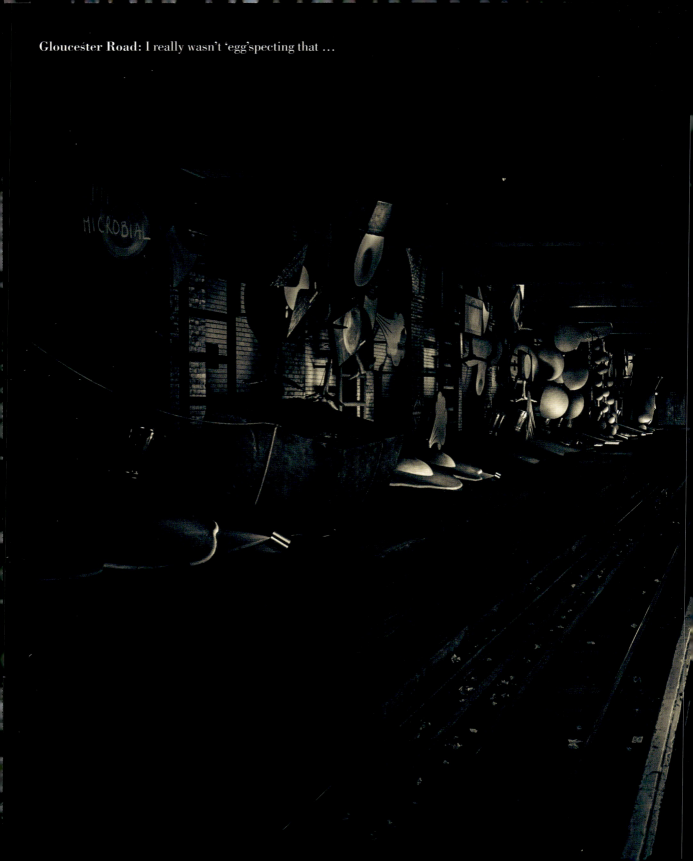

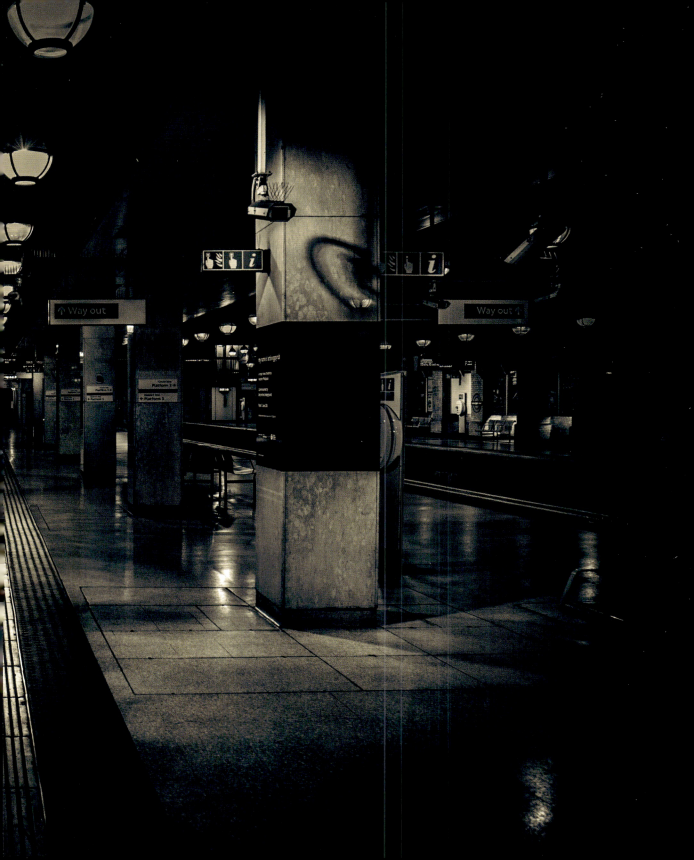

If you enjoyed this title from The History Press

978 0 7509 8781 3

978 0 7509 8597 0